IMAGES
of America

THE PORTUGUESE
IN SAN JOSE

SAUDADE

Ja foi sonho, mas agora	It was a dream, but now
E pura realidade	pure reality
Ha pouco te foste embora	a while ago, you went away
Ja de ti tenho saudade.	already I feel longing.

—Machado Ribeiro

ON THE COVER: Queen Lynette Held and side maids Beverly Kampfen (left) and Dolores Machado (right) walk from the IES Hall to Thirty-fourth Street on their way to Five Wounds National Portuguese Church, where the 1957 queen will be crowned. (Courtesy Vieira family.)

IMAGES
of America

THE PORTUGUESE
IN SAN JOSE

Meg Rogers with support from
the Portuguese Historical Museum

ARCADIA
PUBLISHING

Published by Arcadia Publishing
Charleston, South Carolina

Printed in the United States of America

Library of Congress Catalog Card Number: 2007924208

For all general information contact Arcadia Publishing at:
Telephone 843-853-2070
Fax 843-853-0044
E-mail sales@arcadiapublishing.com
For customer service and orders:
Toll-Free 1-888-313-2665

Visit us on the Internet at www.arcadiapublishing.com

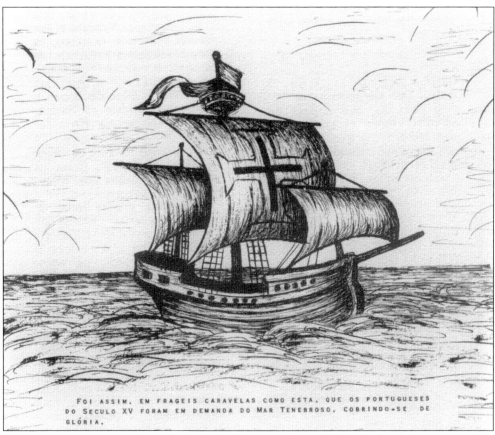

CARAVELA, 1957. Antonio Furtado drew this illustration to include in his book *Açores e o Volcao dos Capelinhos*. It depicts the *caravela* used by 15th-century Portuguese explorers who traversed the dangerous high seas. (Courtesy AF.)

CONTENTS

ACKNOWLEDGMENTS

Working as a contributing editor for Arcadia's Images of America: *Alviso*, I found numerous Portuguese references. Soon Edith Walters welcomed Robert Burrill and me to the Portuguese Heritage Museum in History Park to research the Portuguese contributions to the Valley of Heart's Delight.

This book is a tapestry of personal narratives from first-, second-, and third-wave Portuguese immigrants interwoven with material from Portuguese fraternal societies and excerpts from the Portuguese Heritage Publications of California. I am grateful to all those in the community who opened up their homes and places of business to meet with me, including the following: Edith Mattos Lewis Walter and Joe Machado of the Portuguese Historical Museum; Vicky Borba Machado; Richard Alves; Margaret "Peggy" Vargas; Carlos Almeida of Uniao Portuguesa do Estado da California, who knows every book in the J. A. Freitas Library like the back of his hand; Dick Carlo; Gina and Antonio Furtado and their lovely assistant, Filomena; Goretti Silveira; Clare Alves; Mabel Silva Mattos; the Portuguese Organization for Social Services and Opportunities (POSSO); Dr. Decio Oliveira and the Portuguese Athletic Club; Tony Goulart of the Portuguese Heritage Publications of California, Mac and Madeline Moitozo; Batista, Davide, and Dolores Vieira; and Father Antonio of Five Wounds National Portuguese Church. To any who submitted images or notations that do not appear here, I look forward to future publications.

I am grateful to Robert Burrill and Dr. Foxglove for early scanning assistance; to Lynn Rogers for editorial help, layout inspiration, and creative mentorship; and to my great-great-grandmother Ridley, who taught school in the Alviso district of San Jose. She continues to inspire me. Like the Portuguese, she worked hard—with humility and resourcefulness—to build leaders that would make San Jose blossom into a city of roses.

A portion of this book's proceeds will go to support POSSO and the Portuguese Historical Museum in History Park.

INTRODUCTION

In the 1840s, Portuguese whalers, ship jumpers, and Gold Rush immigrants came to California. Gold was the lure, but land was the anchor. Although many stayed in San Diego to fish, most migrated into the Central Valley and Santa Clara Valley to farm. Until they could earn their own land, many worked in support services like hotels and barbershops. Agriculture and construction were big industries of post–Gold Rush California.

Azorean immigration to the Valley of Heart's Delight occurred in three main waves. From 1849 to 1880, dreams of striking it rich in the Gold Rush and through whaling lured the Azoreans over the sea. During this period, many intrepid Azorean youths fled the draft to escape the unjust wars of mainland Portugal. Young men stowed away aboard whaling vessels bound for the New World; many were caught by angry captains who threatened to throw them into the sea. Others dreaming of a better, more prosperous life in America signed on as slave labor aboard craft taking them to the promised land; intolerable conditions aboard these vessels often forced Azorean whalers to jump ship onto the shores of California. When whaling grew tiresome and mining did not pan out, Azorean immigrants worked in Gold Rush support services or found work on dairies and farms in the Santa Clara Valley. From 1880 to 1922, immigrants called their relatives to the California frontier, causing a second wave. Land was plentiful; immigrants willing to work hard and suffer through delayed gratification could rise up from farmhand or dairy worker to farm and cattle owner. Many in this generation were able to achieve the American dream of home ownership.

Ties to the homeland were strong, and many Azoreans experienced *saudade* thinking about their island. *Saudade* is a Portuguese word with no exact translation; it stands for something lost that can never be regained. Many fado songs express this emotion. The passage to the New World was a rough one, and for many, the longing for home never really went away. Holy Ghost societies helped Azorean immigrants remember the beautiful processions along the streets of their home islands. In San Jose, like other *colonias*, the Portuguese gradually established fraternal societies to meet the growing needs of their community. Irmando do Espirito Santo (IES) and Five Wounds National Portuguese Church are jewels in the crown of California social and religious institutions.

Pres. Woodrow Wilson attempted to curtail Portuguese immigration in 1917 with a literacy test for Azorean immigrants, 80 percent of whom were unschooled. During Prohibition, some intrepid Portuguese in San Jose stomped grapes in barrels in their basements, making white lightning, wine, and root beer with yeast cakes. Sometimes when the priest was visiting, caps blew off and there were explosions in the closets.

In 1924, anti-immigration laws decreased the quota of immigrants from any Portuguese territory to 440. For 40 years, Portuguese immigrants trickled into San Jose, some obtaining visas after a short stay in Canada or Brazil, others being "called" by distant relatives. The Portuguese worked hard to maintain their foothold on the American dream. During the Great Depression, many of the Portuguese in San Jose reverted to subsistence farming and working several jobs in order to survive. Colorful figures following the second wave include Tony Santos, the fiery Portuguese earth worker from Hawaii who became the biggest landholder in the Alviso district, and John

Ignacio Silva, who founded the Dairy Labor Union in San Jose in 1933. The 1940s brought hard work and solidarity for the whole community. Everyone pitched in to win the war.

Following the eruption of Capelinhos in 1957, Congress, under the leadership of Sen. John F. Kennedy of Massachusetts and Sen. John Pastore of Rhode Island, passed a relief act allowing 1,500 families from Faial who were victims of the volcano to immigrate to the New World. Thousands of new Azorean immigrants were called and sponsored by their families in America following this relief act. Believing the quota system was an injustice, Kennedy fought for its elimination; he wanted immigration to be based on skill sets needed in America and not on ethnicity. After Kennedy's death in 1964, President Johnson signed Kennedy's bill lifting the unfair European immigration quotas.

The last great wave of Portuguese immigrants flowed into the Santa Clara Valley during the 1960s and 1970s. Third-wave immigrants came for economic and educational opportunity, to escape the draft to Portuguese colonies in Africa, and to rejoin their families across the sea. Interesting immigrants during this third wave include San Jose's Vicky Borba Machado, who came from the Azores as a child in the 1950s and later became a top Santa Clara County social worker. She cofounded POSSO (Portuguese Organization for Social Services and Opportunities) with her husband, Joe Machado, who also spearheaded the Portuguese Historical Museum. According to a study by Harvard professor Dr. Francis M. Rogers, 114,931 immigrants born in Portugal and the Azores resided in the United States in 1970. In the 1990s, immigrants from Portugal grew to include 1.4 percent of the total American population.

One

COMING TO AMERICA

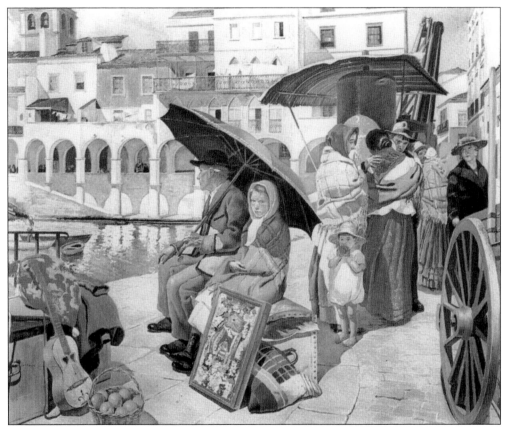

Os EMIGRANTES (THE EMIGRANTS). This painting depicts the rich cultural heritage the Azorean immigrants brought to the New World. The lure to cross the sea was powerful. The Azores offered little in the way of economic or educational opportunity. Immigrants were drawn to reports such as this from the *San Francisco Call Atlas* of 1910, which described San Jose as "a charming home city that has won it the title, 'The Garden City' . . . with growth in bank deposits from $15,504,767 in 1907 to $27,828,978 in 1910." Immigrants willing to commit themselves to delayed gratification in the fields could work and save in order to buy a small piece of land to give them a foothold on the American dream. (Painting by Domingos Rebelo; courtesy Carlos Machado Museum, Ponta Delgada, San Miguel, Azores.)

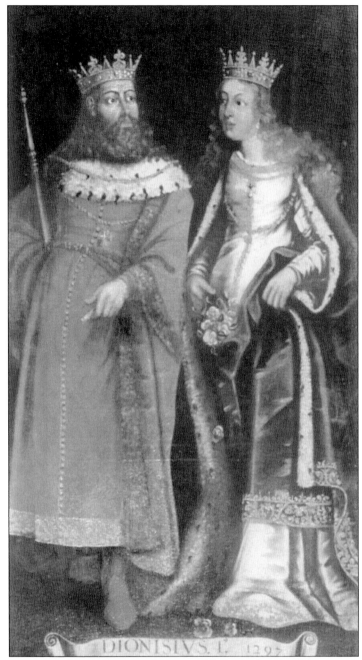

KING DOM DINIS AND QUEEN ISABEL. Born in 1271 to Pedro III of Aragon, Isabel acted on faith from an early age. She was betrothed at 12 to the Dom Dinis, "the Farmer King," who would improve agriculture and create the University of Coimbra. Beyond her queenly duties, she dedicated herself to providing food and lodging to poor pilgrims and orphans. Her husband would sometimes protest her charity. On one such occasion, Queen Isabel hid bread for the poor from her husband in her cloak; she prayed that her husband would not discover her generosity, and a miracle occurred: the bread under her cloak turned to roses. In the Azores, everyone recites "The Miracle of the Roses." San Jose's Holy Ghost Festa is held in her honor. (Courtesy PHPC.)

CAMOES. Pictured at left is an engraving by Antunes depicting Camoes, one of the greatest Portuguese poets. Each June 10th, San Jose Portuguese scholars gather at the Portuguese Athletic Club to contemplate Camoes's timeless lines. *Alma Minha* describes his impossible love affair with Johanna Noronha: *"Alma Minha gentil que te partiste*—my gentle soul you went away." (Courtesy DO.)

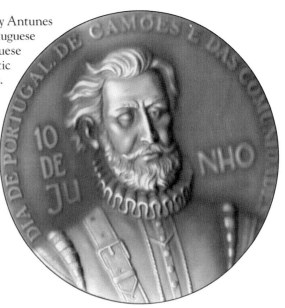

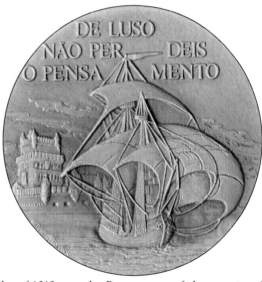

CABRILHO AND A CARAVELA. The papal order of 1312 sent the Portuguese to fight enemies of Christianity with the expansion of the Portuguese empire during the Age of Discovery. In the 1400s, Prince Henry of Portugal launched an exploration under the Order of the Christ. In 1427, the Portuguese discovered the Azores, the place of origin for many Portuguese in California. In 1538, under the Spanish crown, Portuguese explorer Joao Rodrigues Cabrilho voyaged to South America and then to the unknown north, or Alta California. From San Diego Bay, he came as far as sighting Santa Cruz and the Santa Rosa "Islands." Others followed Cabrilho's route. Even after Portugal's decline in 1640, its spirit of exploration persisted. (Left photograph courtesy EMLW; right photograph courtesy DO.)

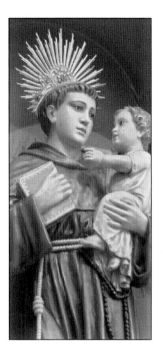

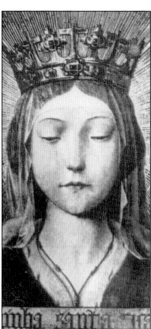

ST. ANTHONY AND ST. ISABEL.
Born to Portuguese nobility
in 1195, Anthony entered the
Franciscan order to minister to
the Moors; stopped by ill health,
he preached forcibly. After
his death in 1231, children in
Padua called out, "Our Father,
St. Anthony, is dead." At Five
Wounds, the Brotherhood
of St. Antonio holds a festa
in his honor during which
participants give *promessas*
asking for intercession to help
the sick. He is the patron saint
of Uniao Portuguesa do Estado
da California (UPEC). In 1652,
Queen Isabel was canonized as
St. Isabel. Her glass sarcophagus
is still in Coimbra today. (Left
photograph courtesy JAFL; right
photograph courtesy PHPC.)

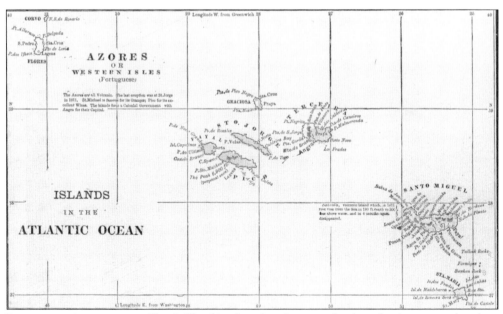

LEGENDARY ARCHIPELAGO. Plato's *Chrythias* describes the nine islands in the Azorean archipelago
as peaks of the mythical Atlantis. The Seven Cities Lake of San Miguel consists of two lakes in
an ancient crater. Legend states that when an Atlantean princess died, her shoes fell into one
lake, which turned green, and her dress slipped into the other lake, which turned blue. Each
island has its own festa, including Pico's Bom Jesus, Terceira's Holy Ghost, and Sao Jorge's Bodo
de Leite. (Courtesy Carlos Almeida.)

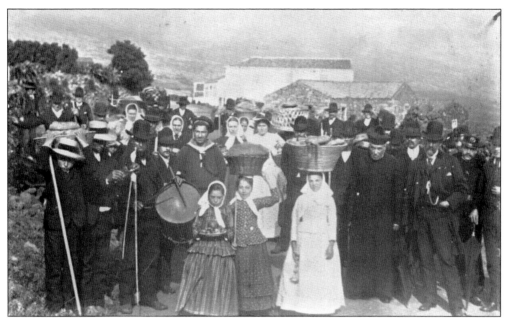

HOLY GHOST FESTAS IN THE 19TH CENTURY. Bread is passed out to the people for free after the coronation of the queen as a celebration of Isabel's ministry to the poor. The Portuguese Heritage Publications book *The Holy Ghost Festa* features an article by Fr. Leonel Noia entitled "The Holy Ghost in California since the 1970's: Personal Observation." Noia describes the Holy Ghost Festa as the "fioretti of the people in the California Diaspora. Fioretti means the little flowers in the open field that grow when and where they are least expected. In regards to the people it is a metaphor for the memories of one's life that remain. . . . These fioretti of Portuguese/Azorean descendants, as in this El Dorado, perennially changing color, so will the festas, as the cultural dress of our people will be on forever." (Courtesy Oliveira Martins.)

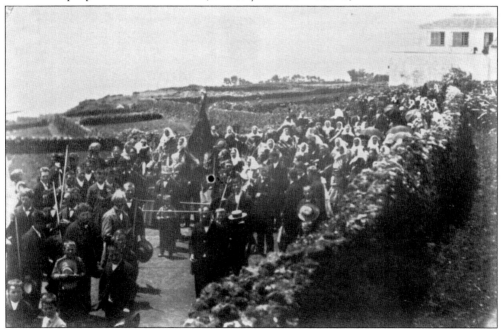

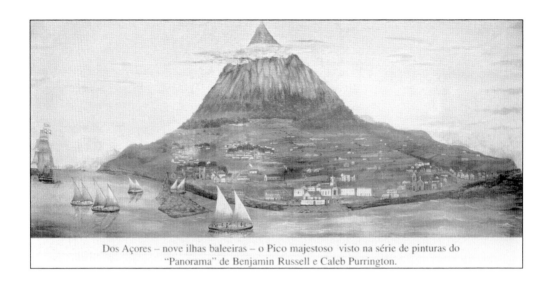

Dos Açores – nove ilhas baleeiras – o Pico majestoso visto na série de pinturas do
"Panorama" de Benjamin Russell e Caleb Purrington.

SHIPS LEAVE FAIAL AND PICO. The painting above, by Benjamin Russell and Caleb Purrington, shows the majestic peak of Pico Island in the Azores; below is a scene in Horta, where Faial is the principal port. Many Portuguese immigrants crossed the Atlantic working aboard whaling vessels in order to escape the draft. Once they reached the whaling cities of Monterey and San Luis Obispo, many abandoned whaling for the less dangerous occupations of dairy farmer and field hand. After the Gold Rush, San Jose and Santa Clara became landing places for the Portuguese who had earlier settled in San Leandro and San Diego. (Courtesy *Mar de baleias de baleeiros* by Joao Alfonso and PHM.)

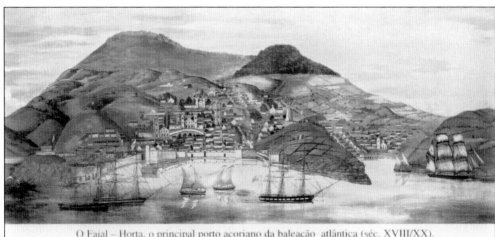

O Faial – Horta, o principal porto açoriano da baleação atlântica (séc. XVIII/XX).

WEDDING TIN AND THE SS VEGA. This tin (right) celebrates the August 15, 1891, union of Joe Francisco Vargas and Anna Caetana Lourenco. In 1885, Vargas came from Faial to Boston on the SS *Vega* (below); in 1891, Lourenco traveled via steerage from Flores to New York. Conditions were terrible and she got very sick. When passengers combed lice onto the deck, the captain called them *porcas* (pigs). Upon arrival, Lourenco cried herself to sleep—her brother Manuel's wife, Minnie Delphina, had arranged a marriage with Joe Francisco Vargas so the couple would not have to support her. Joe Vargas's uncle "Tio Morgado" secured a job for Joe on the Curtner ranch in Warm Springs, farming hay. Vargas asked Henry Curtner for a little shack, and instead he gave him lumber to build one, with no running water. Anna wallpapered the home with newspaper. When the walls got soiled, she put up fresh paper by light from kerosene lamps. (Courtesy SV.)

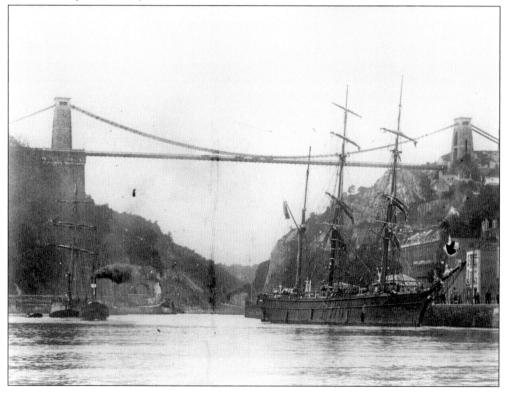

FROM WHALER TO FARMER. Manuel Francisco Vargas (left) worked as a whaler in Faial and Rhode Island in the late 1800s. He never emigrated, but his four sons—Manuel Francisco Vargas Jr., Jose Francisco Vargas, Antonio Francisco Vargas, and Francisco Antonio Vargas—did. Jose Francisco Vargas immigrated to Boston in 1885 on the SS *Benguella*, taking a train to California. Joe's uncle "Tio Morgado" called him to work in Warm Springs for Henry Curtner (right) on part of the original Higuerra Grant. According to daughter Rosie Alice Pereira, Francisco had mined for gold with his father in the 1850s. Francisco decided to start a life in California, but family legend states that his father took off for Brazil and was never heard from again. Curtner employed many Azorean farm workers and gave them residences on the property; he had found many of these workers on the docks of San Francisco. Francisco Vargas worked there with Thomas Pereira, who sent for his sister Filomena Pereira. Francisco and Filomena fell in love and lived together on the Curtner ranch. (Courtesy Susan Vargas and Graves's *Portuguese in Agriculture*.)

TRAGEDY STRUCK A FAMILY. Pictured in 1917 are, from left to right, Dan, Mary, Rose, and Manuel Mattos. Manuel Mattos came to San Jose at age 21. In Pico, he saw his mother putting clothes on a lava rock to dry. She slipped on the rock, and a giant wave swept her out to sea. (Courtesy EMLW.)

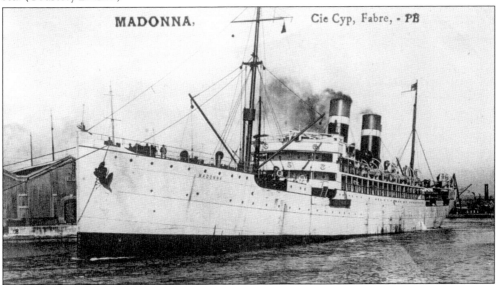

PASSAGE TO A NEW WORLD, 1913. Jose Ignacio Maciel immigrated on the SS *Madonna* to avoid the draft to Africa. He left Marseilles on June 27, 1913; Lisbon on July 1; Madeira, July 3; Terceira and Miguel, July 4; and Faial, July 6, with his cousin Francisco Pinheiro Silveira. On July 12, they arrived in Rhode Island. Jose Maciel was stunned by the bustling activity after his tiny village on Faial. (Courtesy SV.)

except one boat's crew, and ordered to go in 20
to church and give God thanks for all
the mercies he has given us &. Next mond.
we discharged our carpenter sick the who-
le while from home, and discharge our
blacksmith too, that he has been with the
scurvy on for the past three months.
While at Mahii, we toke a quantity of Irish
and sweet botatoes, some fire wood, water,
and a few other things that we were in
the need of; and discharged our whale
bone, and shiped it on board of the Sou-
th Sims, to go home (of New Bedford)and
I signed the ship's Articles there before the
American Council for the remainings of the
voage.

ANDRADE WHALING LOG, 1859. Written off the coast of Hawaii in 1859 by Manuel S. Andrade of Faial, this whaling log (above) relates the hardships of his life at sea: "Except one boat's crew and ordered to go in to church and give God thanks for all the mercies he has given us. Next mond[ay] we discharged our carpenter sick the whole while from home, and discharge our blacksmith too, that he has been with the scurvy on for the past three months. While at Mauii we toke a quantity of Irish and sweet botatoes, some fire wood, water, and a few other things that we were in the need of; and discharged our whale bone, and shiped it on board of the Louth Sims, to go home (of New Bedford) and I signed the ship's Articles there before the American Council for the remainings of the voage." (Courtesy *Mar de baleias de baleeiros* by Joao Alfonso.)

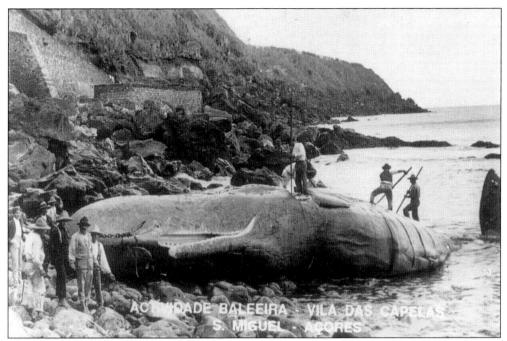

SAN MIGUEL WHALING STATION, 1920s. Men hand-spear a sperm whale caught off the coast of San Miguel. Many early settlers made their way to California through whaling ships. After spearing, whale flesh would be unloaded and put into six-foot cauldrons. Once a wood fire was lit, the fat and oil would rise to the top. The whole whale was used—the teeth for ivory artwork, the oil for lighting, and the other parts for pharmaceuticals. (Courtesy Carlos Almeida.)

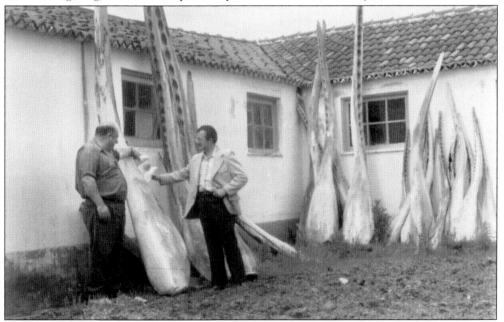

WHALE TEETH. An unidentified manager of the whaling station inspects the jaws of the whale while Carlos Almeida stands on the right. Today whaling is outlawed because many of the species have been threatened with extinction, including the humpback. (Courtesy Carlos Almeida.)

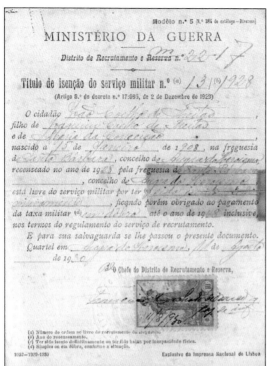

Modèlo n.° 5 [N.° 384 de catálogo—Diversos]

MINISTÉRIO DA GUERRA

Distrito de Recrutamento e Reserva n.°

Titulo de isenção do serviço militar n.° (a)

(Artigo 8.° do decreto n.° 17:695, de 2 de Dezembro de 1929)

DRAFT NOTICE. Joao Coelho Freitas of Santa Barbara, Terceira, received this call to war, good until 1948. In 1966 (amid controversy over Portugal's colonial war), Freitas's sons John and Joe were drafted to war in Mozambique. The family immigrated to Brazil in 1966–1967, then to the United States. Joe was drafted to Vietnam and classified 1-A until the lottery gave him a high number and reclassified him 1-Y. Many of John's friends took asylum in Canada. (Courtesy Alice Freitas Texeira.)

WAVES OF IMMIGRATION. Portuguese historian Joe Machado describes three waves of immigration instead of the two depicted in this map: from 1850 to 1880, predominately for the Gold Rush and whaling; from 1880 to 1923, for economic opportunity; and from 1960 to the 1970s, following the passage of Senator Kennedy's bill lifting unfair European immigration quotas. (Courtesy JAFL.)

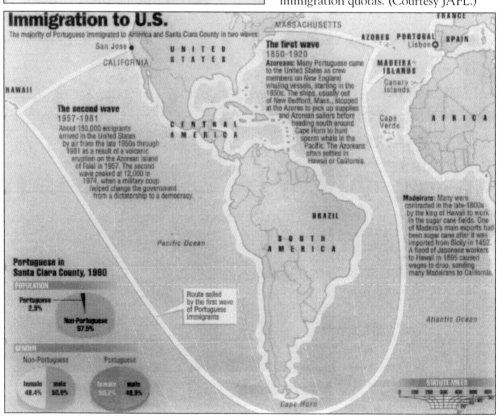

Immigration to U.S.

The majority of Portuguese immigrated to America and Santa Clara County in two waves:

The first wave
1850-1920
Azoreans: Many Portuguese came to the United States as crew members on New England whaling vessels, starting in the 1850s. The ships, usually out of New Bedford, Mass., stopped at the Azores to pick up supplies and Azorean sailors before heading south around Cape Horn to hunt sperm whale in the Pacific. The Azoreans often settled in Hawaii or California.

The second wave
1957-1981
About 150,000 emigrants arrived in the United States by air from the late 1950s through 1981 as a result of a volcanic eruption on the Azorean island of Faial in 1957. The second wave peaked at 12,000 in 1974, when a military coup helped change the government from a dictatorship to a democracy.

Madeirans: Many were contracted in the late-1800s by the king of Hawaii to work in the sugar cane fields. One of Madeira's main exports had been sugar cane after it was imported from Sicily in 1452. A flood of Japanese workers to Hawaii in 1895 caused wages to drop, sending many Madeirans to California.

Route sailed by the first wave of Portuguese immigrants

Portuguese in Santa Clara County, 1990

POPULATION

Portuguese 2.5%
Non-Portuguese 97.5%

GENDER

Non-Portuguese
female 49.4% male 50.6%

Portuguese
female 50.2% male 49.8%

JOHN NUNES, 1850. Gold miners such as Nunes, the first known Portuguese settler in Santa Clara County, flocked to the Sierra Nevada after gold was discovered in 1849. Many Portuguese first came to California looking for gold. A few went into gold support services, opening shops and markets to supply the growing boomtowns. Those who did not strike it rich in the mines found California's real gold in the fertile valleys of San Fernando and Santa Clara. (Courtesy JM.)

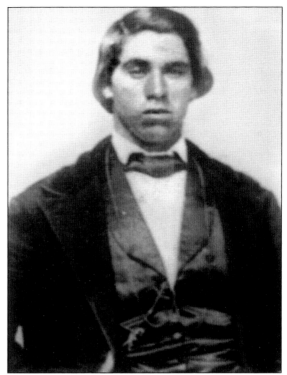

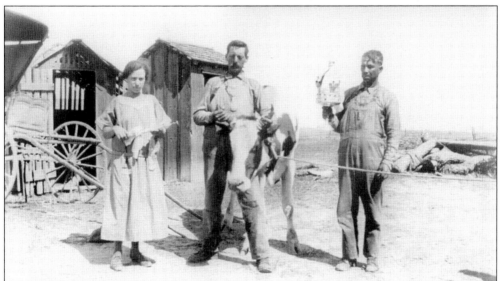

THE PROMESSA, 1910. Portuguese settlers in Stratford hold the Holy Ghost crown. Azorean immigrants give a *promessa* (in this case their best cow), sacrificing something essential in order to receive a blessing. This rustic image reveals the spirituality Azorean immigrants brought to the New World. Their Holy Spirit rites are based in Catholic theology; 12th-century abbot Joachim of Fiori predicted the Age of the Holy Spirit of peace, charity, and universal spirituality. His ideas inspired many, including Dante, Grail scholars, and Franciscans. In 1256, it was more popular than Roman tenets and subsequently banned, but Azoreans withstood the attempts to eliminate their tradition. (Courtesy PHPC.)

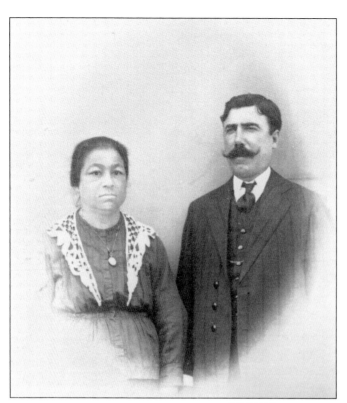

OLD WORLD FAMILY. The grandparents of Manuel Moitozo pose on Faial in the Azores. After her husband died, Luisa Duarte came to America with her daughter Angelica and son-in-law John Moitozo around 1912. With the determination of his grandmother, Manuel Moitozo would one day bequeath a rich agricultural heritage to his descendants and San Jose residents. (Courtesy Moitozo.)

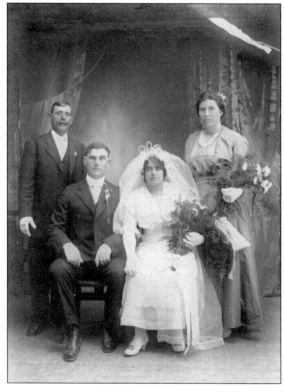

MANUEL MOITOZO, WEDDING DAY. From left to right are Louis Dutra, Manuel Moitozo, Isabel Rose Moitozo, and Manuel's sister Mary Dutra. Manuel grew up on Faial and did not get to see his father, John Garcia Moitozo, who was in the United States, until he was seven. Manuel emigrated in order to avoid the draft at age 21, working on a dairy farm in Vallejo. In 1916, he married Isabel. Their union brought Madeline in 1917, followed by Edward (who died), Manuel, and Anthony "Mac." (Courtesy Moitozo.)

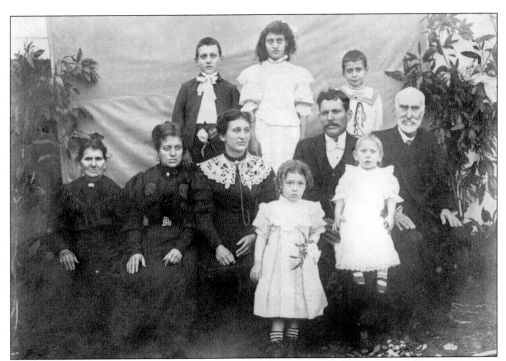

CARVALHAL DA SILVEIRA FAMILY, 1898. In 1530, the Carvalhal family came to Terceira, Azores. In 1566, Dias Francisco da Carvalhal served as a knight to Africa under King Dom Manuel. Pictured above, from left to right, are the following: (first row) Joao and Antonio Carvalhal da Silveira; (second row) Luisa and Maria Serafina da Carvalhal, Jose Machado Borba da Silveira, and Manuel Carvalhal Azevedo (a judge in Calheta); (third row) Jose, Maria, and Alberto Carvalhal da Silveira. This photograph was taken in Sao Jorge after Jose Silveira worked on a Novato dairy. He had registered all his children as American citizens, enabling his son Alberto Silveira to immigrate to America. In 1948, Alberto became president of UPEC. Jose's other son, Joao Carvalhal da Silveira, helped David and Eduina Carvalhal da Silveira immigrate to Patterson, California (with Alberto), before moving to Palo Alto (Eduina worked as a maid at Ricky's Hyatt House) and then to San Jose. David Silveira (shown at right in 1933 at age four) is the father of Goretti Silveira, owner of Dom Dinis. (Courtesy GS.)

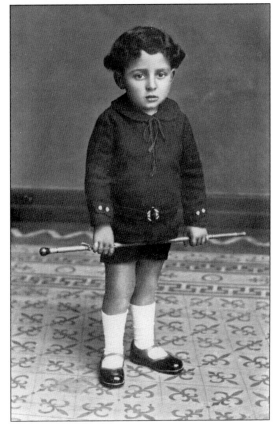

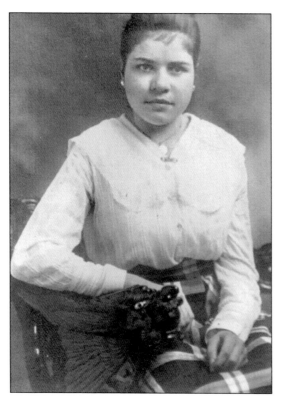

MARY VIEIRA, 1917. Born in December 1901, Mary Vieira was 16 years old in this photograph. She died a week before her 17th birthday during the flu epidemic of October 1918. A week later, her brother succumbed. During harrowing times, the Portuguese of San Jose turned to their mutual aid societies for help. (Courtesy EMLW.)

ALL DECKED OUT. In the early 1900s, Joseph and Anna Correia wed in San Jose. Anna ordered a wedding outfit from a seamstress that included leg-of-mutton sleeves. Her hair and his lapel were graced with apple blossom flowers and buds. The couple lived with Edith and Joe Correia on a vegetable farm on San Jose's Wayne Avenue. (Courtesy EMLW.)

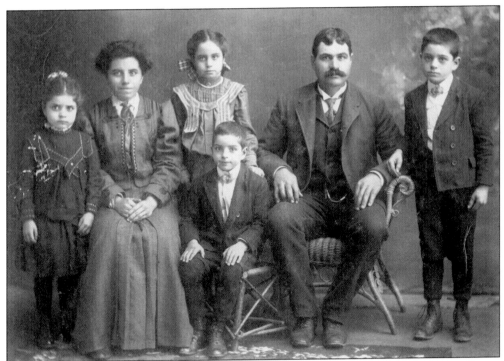

VIEIRA FAMILY, C. 1909. Seen here, from left to right, are Mary Vieira, Mary Corriera Vieira, Rose Vieira, Joe Vieira, Domingo Vieira, and Manuel Vieira. Both little Mary and Manuel perished in the flu epidemic of 1918. (Courtesy EMLW.)

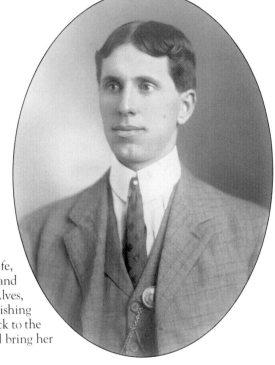

JOHN ALVES, 1910. Dreaming of a better life, John Alves sailed from Faial to Ellis Island and traveled by rail to join his brother Antonio Alves, a successful barber in Saratoga. After establishing himself in the United States, John went back to the Azores to wed Mary Azevedo E. Melo and bring her to the New World. (Courtesy RA.)

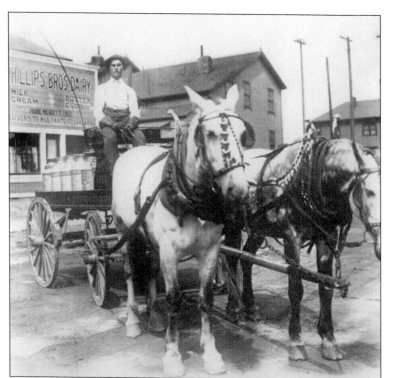

PHILLIPS BROTHERS DAIRY TRUCK. Dairy hands on the Moitozo ranch in San Jose would load 10-gallon cans into the truck. Eventually the dairy dried up; the Moitozos sold prunes, the state's biggest crop. Alice Moitozo still has the bronze milk can her father-in-law, Manuel, kept as a souvenir from his work at the Phillips Brothers Dairy in San Leandro. The can currently props open the corral for the family's indoor-outdoor pet pig, Porky. (Courtesy Alice Moitozo.)

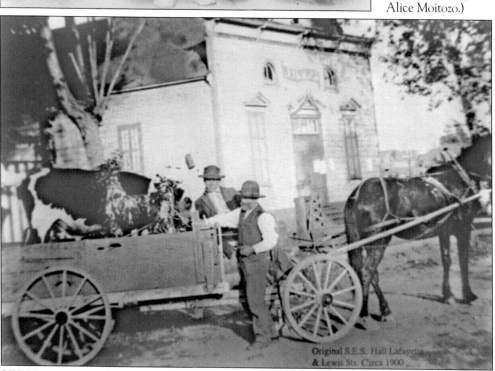

SES HALL, 1900. This photograph shows the original Sociedade do Espirito Santo (SES) Hall on Lafayette and Lewis Streets in Santa Clara. A large Portuguese American community enjoys the hall, founded in 1895. (Courtesy JAFL.)

ON THE DOWNING RANCH. Joseph Silva stands on Downing Ranch in Milpitas, where Portuguese farmers prospered. Milpitas historian Robert Burrill states that, since the Santa Clara Valley was full of artesian wells and the Guadalupe River flooded, the best farming area for hay and produce was the Milpitas Hills and East San Jose. Produce grown there and processed in San Jose was shipped out though Alviso to feed a growing state. (Courtesy MM.)

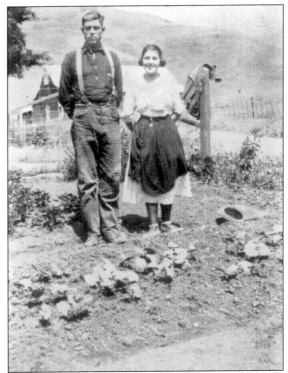

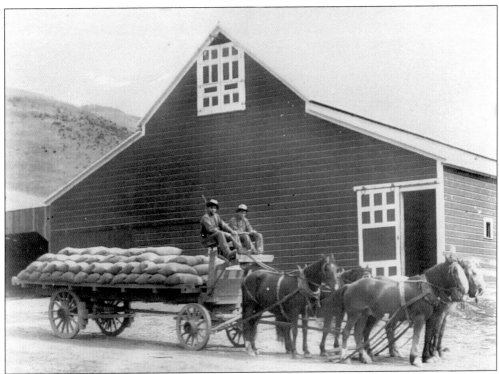

TAKING PRUNES TO MARKET, 1910. Joseph Rose (left) and Anton Vieira Silva of the Downing Ranch carry dried prunes to sell on Market Street in San Jose in the early fall. (Courtesy MM.)

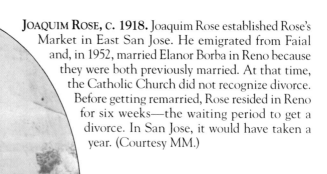

JOAQUIM ROSE, C. 1918. Joaquim Rose established Rose's Market in East San Jose. He emigrated from Faial and, in 1952, married Elanor Borba in Reno because they were both previously married. At that time, the Catholic Church did not recognize divorce. Before getting remarried, Rose resided in Reno for six weeks—the waiting period to get a divorce. In San Jose, it would have taken a year. (Courtesy MM.)

SANTA CLARA MAP. Portuguese settlements in the valley included Mountain View, Santa Clara, San Jose, Milpitas, and small townships. Azoreans, used to terrace farming near the craggy cliffs, made "a thousand gardens" on Milpitas and the East San Jose foothills; according to Milpitas historian Robert Burrill, *Milpitas* means "a thousand gardens." (Until 1911, East San Jose had a mayor and town hall on Thirty-second Street.) San Jose's Portuguese immigrants established two Holy Ghost halls—the IES in 1914 and much later the Aliança Jorgense, which celebrates the festas as performed in the Azores. (Courtesy PHPC.)

RANCH ON MOUNT HAMILTON. Rita Nunes Vargas (right) and her husband, Frank Pereira Vargas, owned the ranch (below) on Clayton Road near Mount Hamilton. Pictured, rows of apricots air dry before being put in the sulfur house. The Vargas family ranch consisted of prunes, a small vineyard, horses, cows, pigs, ducks, chickens, and geese. Their daughter Grace became Marie Imaculada of the Notre Dame Order, a religious sister and educator, and their son Frank was an agricultural developer in the valley. (Courtesy PV.)

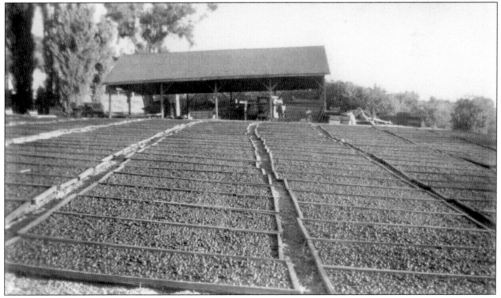

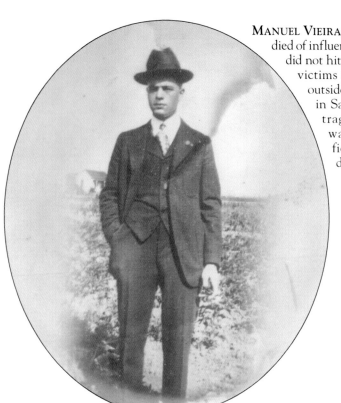

MANUEL VIEIRA, 1917. In 1918, Manuel Vieira died of influenza. Even though the epidemic did not hit as hard in California because victims used masks when they went outside, many Portuguese residents in San Jose lost their lives in this tragic time. This photograph was taken in the Vieiras' field not long before Manuel died. (Courtesy EMLW.)

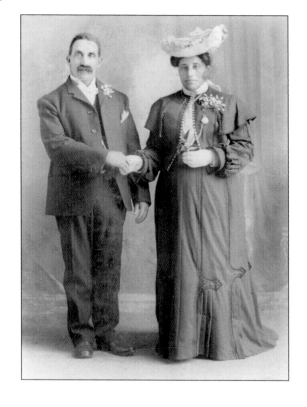

STRONG WIDOW. Senhorinha dos Almos Azevedo came from Sao Jorge and settled in San Jose, where she married Jose Azevedo in 1903. After saving, the couple purchased 96 flatland and hill acres on Hillsdale Avenue. Senhorinha raised goats and sold milk, butter, and eggs. When her husband died in 1915, she raised Mary and Adelina alone. She once killed a coyote with a shovel in order to save her chickens. Mary helped run the dairy until her mother's death in 1965. (Photograph by Denninger Studio; courtesy Dolores Vieira.)

FIVE WOUNDS'S FIRST QUEEN.
Margaret A. Cardoza (left) appears in
1918 with her sister Irene, who worked
at M. Blum and Company Clothing
on First Street in San Jose. Margaret
was the first queen of Five Wounds
Church. Below, Margaret A. Cardoza,
later Margaret C. Vargas, is pictured on
her elementary school graduation day.
Margaret's granddaughter Peggy recalls
that her grandmother walked from 250
North Twenty-seventh Street to Five
Wounds Church every weekday morning
for the 8:00 mass. (Courtesy PV.)

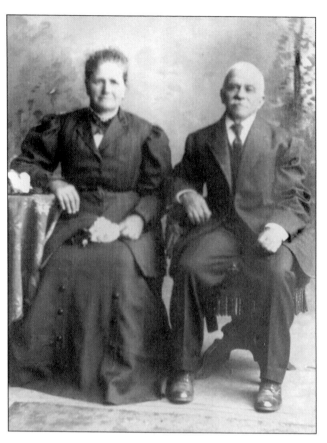

EDITH CORREIA, C. 1920.
Edith and Joseph Correia were first-generation emigrants from the Azores. Edith lived on a vegetable farm in San Jose. She scrubbed and baked all day, preparing her own chickens for dinner. Relief from an endless barrage of chores came when Edith crocheted at night. She made potholders and lace tablecloths to unwind and gave them as gifts. (Courtesy EMLW.)

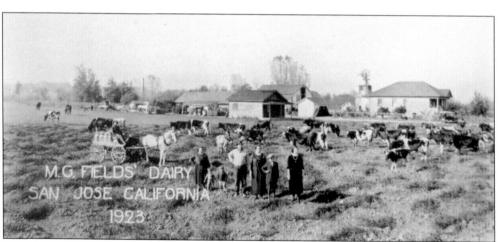

M. G. FIELDS DAIRY, 1923. The M. G. Fields Dairy re-created Old World traditions for the Portuguese settlers from the Azores. Workers at the Fields family dairy epitomized the Portuguese immigrants' industrious persistence and dedication; they worked from sunup to sundown. Money was scarce, but they had plenty to eat. Close-knit groups like the Fields family contributed to the area—politically, socially, and economically—making the valley and, in particular, San Jose a place where milk and honey abounded. (Courtesy PHM.)

ROSE FAMILY, C. 1906. Pictured at a Market Street studio are, from left to right, Rose Garcia, Manuel Garcia Rose, Mary Dolores Rose (Moura), and Joe Rose. Joe grafted walnut varieties in his orchard. Once a tree was in blossom, a limb would be cut, slit, and another branch with buds was put on top. The branch would be wrapped with cloth to keep it stationary and then sealed with black tar or wax. Grafting allowed one tree to produce three or more varieties like early, mid, and late avocados. (Courtesy EMLW.)

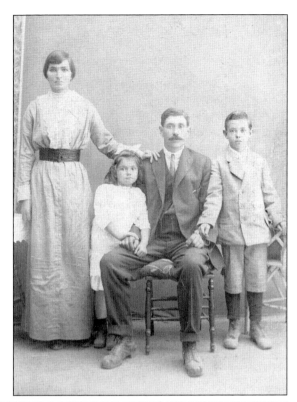

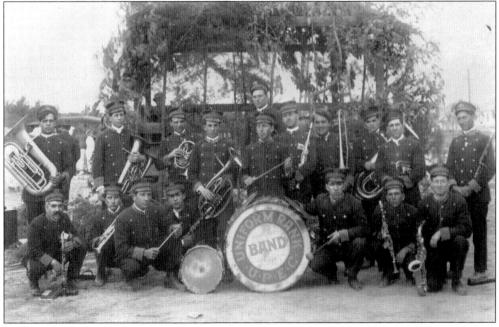

UPEC BAND, 1915. Behind the man with the drum mallet, Joe Freitas holds a clarinet. Standing on the left with the bass horn is Manuel Medeiros, the future conductor of the UPEC band, which performed at the World's Fair on Treasure Island in 1940. The UPEC band played many concerts throughout the state, including San Jose's Alum Rock Park. (Courtesy JAFL.)

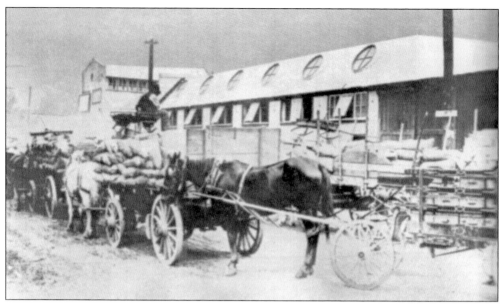

A&C HAM COMPANY. Until the railroad lines went through in 1864, horse-drawn carriages transported produce to packing houses like this one in San Jose. (Courtesy Robert Couchman, *The Sunsweet Story*.)

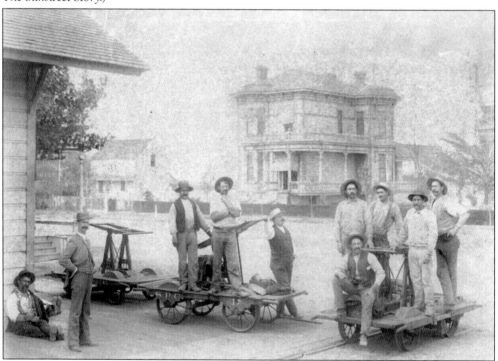

PORTUGUESE TRACK CREW, 1890. Portuguese Americans worked in Alviso (now part of San Jose) first on the train crews and ranches and later for Thomas Foon Chew's Bayside Cannery. Here a Portuguese Southern Pacific Railroad crew takes a break on Elizabeth Street next to the railroad depot (left). Many Portuguese were employed at Thomas Foon Chew's Bayside Cannery, the second largest in the nation. (Courtesy Tom Laine.)

Two

MILK AND HONEY

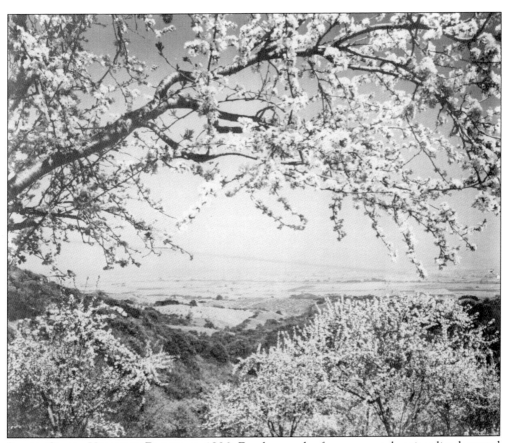

SANTA CLARA VALLEY IN BLOOM, C. 1920. For thousands of years, coastal natives lived around the seasons amid oak groves, artesian wells, and gently flooding rivers. They were overtaken by missionaries, who were overtaken by Mexican ranchers, who were in turn overtaken by Yankees. According to *Alviso, San Jose*, coauthor Lynn Rogers, "With American and European farmers pouring into California after the Gold Rush, by the 1870's vast orchards stretched as far as the eye could see with fragrant blossoms and sweet fruit in an endless sea." Crops grown in the Santa Clara and San Joaquin Valleys were shipped to San Francisco by rail and then out to foreign markets by sea. According to the *San Francisco Call Atlas* of 1910, California fruit and vegetable exports by sea were big business. Prunes were the biggest crop, with 36,586,765 pounds valued at $2,117,652 sent to foreign countries in 1910. Canned fruit was next, with 598, 630 cases valued at $1,795,890 in 1910. At that time, most of Santa Clara's 83,539 inhabitants—including the Portuguese immigrants—worked in fields, canneries, or dairies, supplying the world with the state's rich agricultural bounty. (Courtesy Couchman, *The Sunsweet Story*.)

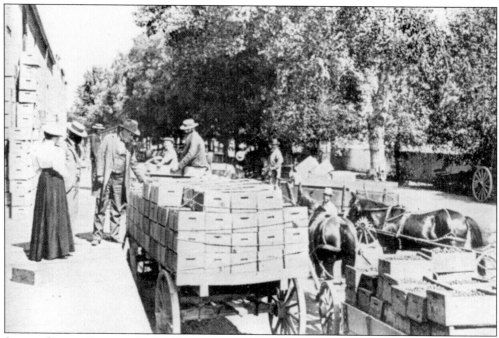

SANTA CLARA COUNTY FRUIT EXCHANGE. The *San Francisco Call Atlas* of 1910 reports that over half of America's prunes came from the Santa Clara Valley, along with three million gallons of wine valued at $12 million. The atlas gives a tree count of the time: "apple 50,410; apricot 553,100; cherry 159,500; fig 2,105; lemon 960; nectarine 1,432; olive 15,120; orange 1,930; peach 631,700; pear 141,000; plum 293,800; prune 5,549,280; quince 2740; other kinds (trees) 426,500. Total 7,829,677. Almond 22,500, walnut 13,759. Total 36,250." (Courtesy Couchman, *The Sunsweet Story*.)

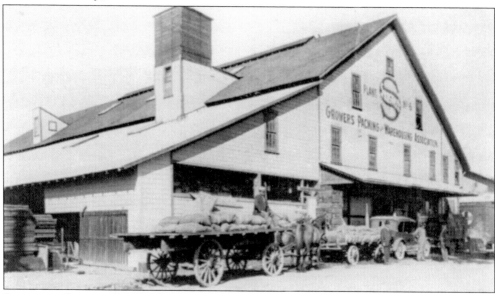

SUNSWEET PACKING PLANT. Dominic Silva owned an apricot orchard in Milpitas. He used to sell his apricots at the Sunsweet Plant No. 6, Growers Packing and Warehousing Association, on Lincoln Avenue in San Jose. (Courtesy Couchman, *The Sunsweet Story*.)

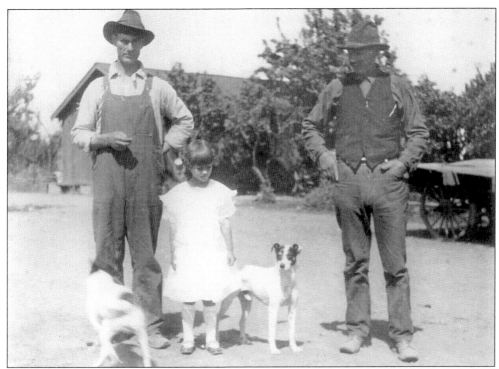

ON THE DUARTE RANCH, 1922. Manuel Moitozo Sr. (left), Madeline Moitozo (center), and uncle Joe Duarte pose for a photograph on the ranch. Madeline recalls, "They got me all dressed up." When she was five or six, the ranch dogs seemed "mean" on the family's Trimble Road ranch where they grew prunes, apricots, and later sold vegetables. (Courtesy Moitozo.)

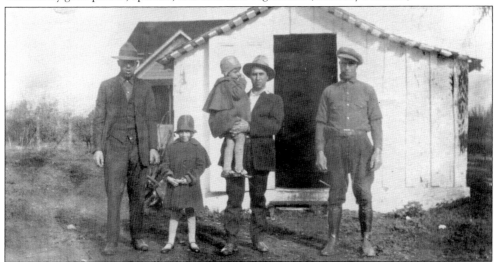

JOE MACHADO'S FAMILY, 1925. In the 1890s, Jose Francisco Pereira immigrated to Stinson Beach and worked in dairies, saving to buy his family a small dairy near King and Tully Roads in San Jose. Their six children, including Mary and Angela (pictured), were raised as farm kids amid hired hands and animal friends. Mary performed chores for the outstanding single-woman dairy farmer Emma Prusch, who lived across the way; she is honored today through Prusch Park. (Courtesy JM.)

FRANK VARGAS. After growing up on his family's ranch near Mount Hamilton, Frank Vargas served as foreman of Louise Kelley's AR-KEL Villa from 1920 to 1950. He created the greatest walnut orchard in the valley and was among the first to dehydrate. Walnuts were washed, green shells hulled, and liquid removed. Excess was sold to the Walnut Association. Frank Vargas married Margaret Cardoza, whose father, Antonio S. Cardoza, owned the A. S. Cardoza Land Excavating Company. (Courtesy PV.)

EAGLES BARBECUE, 1935. Here Frank Vargas (right) and a friend help a fraternal group. After Mrs. Kelley died, Vargas was hired by the City of San Jose as superintendent of city farms. The job was necessary because the city would assume control of old ranches when the owners passed away. Vargas developed the pear ranches where the San Jose Airport now lies. He cultivated other pear farms, accumulating funds to create city parks, including Hunter Hathaway. (Courtesy PV.)

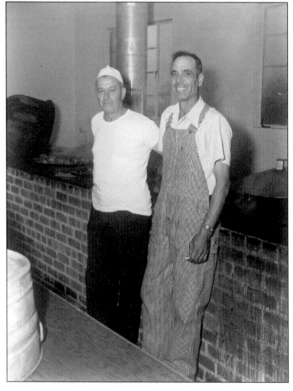

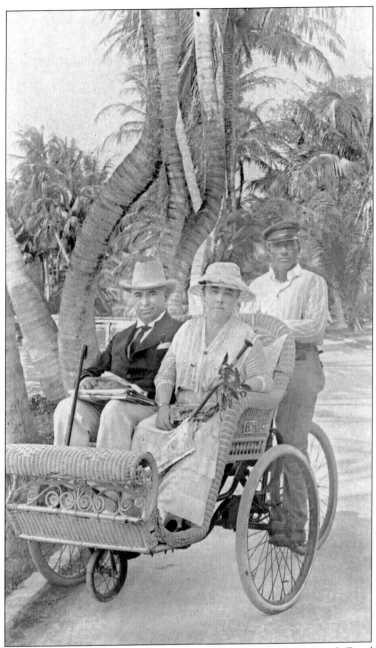

AR-KEL VILLA AND KELLEY PARK. Louise Archer Kelley and her husband, Frank Kelley, are propelled over her estate on Senter Road. She hired Frank Vargas to convert the prune orchard on her villa to walnuts. His daughter Margaret "Peggy" remembers Mrs. Kelley ringing for the help to serve sherry. If Mrs. Kelley's grown children (including a Pulitzer Prize–winning writer and psychiatrist) were five minutes late for a visit, she refused them. Her Asian and African American cooks served elegant dinners. She chain-smoked all day. Before she passed away, Kelley asked Frank Vargas, who had lived there for a long time, to advise her. He brokered the visionary deal in which she donated her estate to the city as Kelley Park. To this day, pillars marked "AR-KEL" (Archer-Kelley Villa) stand on the pepper-tree drive. (Courtesy PV.)

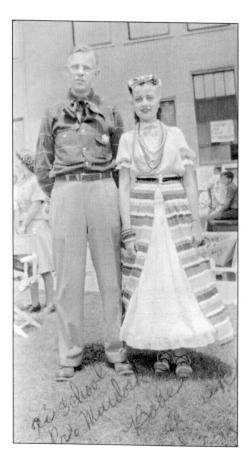

SAN JOSE HIGH SCHOOL, 1939. Frank Vargas's daughter Peggy poses with principal Forrest Murdock the day she was chosen queen of the High School Pageant of the Pacific, related to the World's Fair on Treasure Island. Peggy wears a traditional Portuguese costume that she made from a beach skirt, a blouse, and a bandana. Until the early 1940s, San Jose High School was the only one in the city. It later offered a Portuguese language program. (Courtesy PV.)

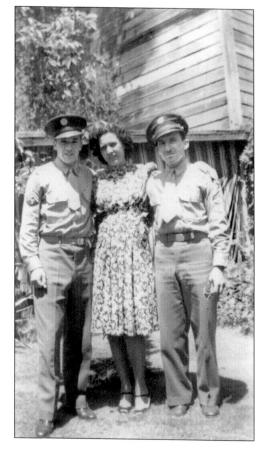

WORLD WAR II IN KELLEY PARK. Frankie Lima (left), Margaret Cardoza Vargas (center), and Mannie Pereira pose for a photograph while the boys, on furlough, visit for a good, home-cooked Portuguese meal. Peggy Vargas recalls that Mrs. Kelley's children, who called her "Grand-mere," would often come over to the Vargas house instead. Kelley's grandson Sean Flavin "was a cutie" who celebrated Peggy Vargas's 75th birthday with her years later. (Courtesy PV.)

40

LONE OAK HOUSE, 1940. On a Sunday after attending Five Wounds Church, the Vargas family gathers at the house provided by Mrs. Kelley. When Peggy had her own children, she brought each baby from the hospital up the pepper-tree drive to his or her grandparents' Lone Oak House. When the city converted the estate, park goers could spy on Vargas family members, who were relieved when the house was eventually razed—no more stares from strangers. (Courtesy PV.)

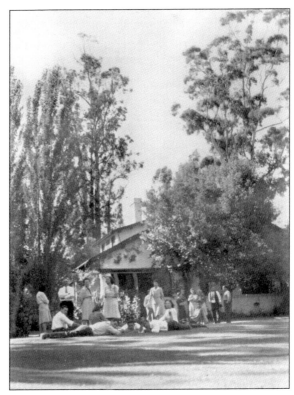

HAPPY HOLLOW. Today Peggy's grandchildren go to Happy Hollow but can no longer stay in the Lone Oak House. San Jose children can, however, enjoy the wonderful park and petting zoo. The basement of one of Mrs. Kelley's homes was used to construct the maze in Happy Hollow. Originally several houses were situated on the estate: AR-KEL in the back, Lone Oak in the center, and Sunset Terrace near Senter and Keyes Streets. (Courtesy PV.)

MOITOZO DAIRY. Above is the dairy on Mauvais Lane in San Jose; below is the milk truck of the Moitozo family dairy in San Francisco. In the 1930s, many Moitozo Dairy workers were Portuguese, as Mexicans mostly worked in the Moitozo vegetable farms and pear orchards. The Moitozo Dairy sold milk wholesale to Oakland and San Francisco. The ranch crops were sold to Shuckles Cannery in Sunnyvale. Moitozo originally had bought the San Jose dairy in 1920 using gold bouillon. In front lay a fruit orchard, and in back were places for potatoes and corn. Everyone in the family worked on the ranch in those days. Kids rode horses to school; there was a stable at Midway School. "Mac" Moitozo reflects on those early values of the Portuguese in San Jose: "People today will not sacrifice their pleasures for advancement." (Courtesy Moitozo.)

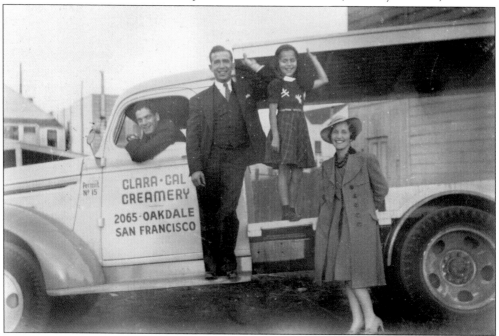

MACHADO FAMILY DAIRY. In 1922, Jose
Machado immigrated from Sao Jorge to
Benecia then moved to Vallejo and finally
San Jose, where he rented a dairy on the
corner of Story and King Roads. The family
purchased a dairy near King and Tully in
1924, and 30 cows became 120. Milk was
distributed to Borden's Creamery in San
Jose. Manuel Machado sold his share of the
dairy to Jose Machado in order to purchase
the Highlight, a bar in Oakland. Jose
Machado sold the dairy in 1955 because
he could not afford the $50,000 cost to
renovate the well. Joe Machado recalls that
a minitornado hit the ranch, lifting the
barn and dropping it into their field. Later
uncured hay spontaneously combusted, and
30 cows perished. Growing up, little Joseph
Machado attached suction cups to the cows'
udders. Hundreds of "working cats" drank
the milk he poured. In the photograph at
right, Joe Machado (left) and Sandy Scatini
play with a pet calf. (Courtesy JM.)

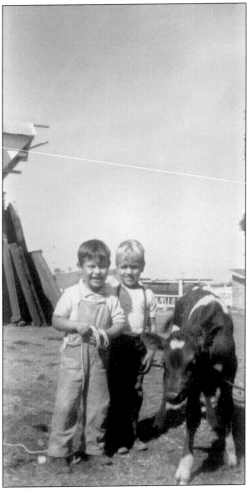

DeFury Brothers Cannery, 1938. The DeFury brothers owned the DeFury Cannery in the Burbank area of San Jose. Here Dominic and Emile DeFury stand in front of their cannery. The Italian brothers employed many of the Portuguese living in the area. Emma Lucille Silva worked at the cannery as a foreman from the 1920s to the 1950s, in addition to her jobs at the California Packing Company and Wools Cannery on Senter Road in San Jose. Silva remembers that while working at the Wools Cannery, she stayed in the cabins for the workers because commuting via horse and buggy took too long. Employees of the Wools Cannery worked six days a week, from Monday through Saturday. (Courtesy MM.)

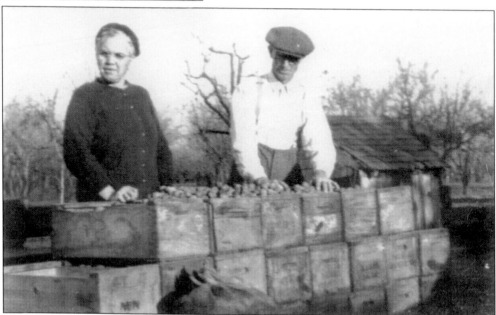

Apricots and Prunes. Rose and Manuel Mattos Sr. take prunes to the dehydrator, where they will be dipped in lye and placed in the sun to dry. Fragile apricots were cut and laid on wooden trays on a track to the smudge house. A sulfur can was ignited and the door shut. The next day, apricots were stacked at an angle in the sun. Drying took up to a week. Dew could spoil them and rain would kill them. Farmers were grateful when the Sunsweet Dehydration Co-Op on Alma and Seventh Streets innovated a quick indoor drying method. (Courtesy EMLW.)

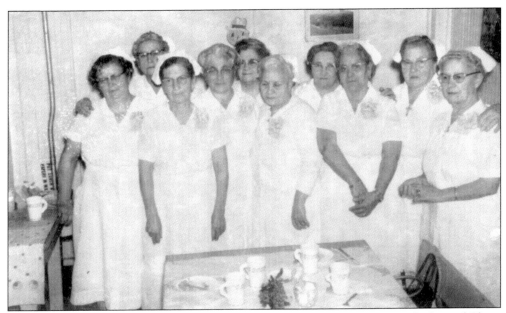

SAN JOSE CANNERY WORKERS, 1949. Located at Sinibar and Stockton Streets, Richmond Chase Cannery canned apricots, peaches, pears, tomatoes, and asparagus and hired Portuguese workers like Maria Pereira (below the smiling man) because they would recruit friends and relatives. Most cannery workers were women. The hours were long and often included evenings and weekends. In 1933, John Ignacio Silva had established the Dairy Union to protect workers' rights. Mary Machado worked for Richmond Chase Cannery from 1925 to 1930. In the late 1950s, the facility became California Canners and Growers. At this time, there was a big strike. (Courtesy JM.)

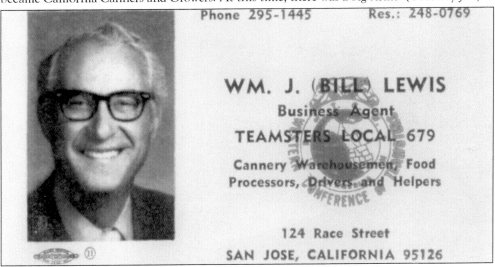

LABOR LEADER WILLIAM LEWIS. From the 1950s to the 1970s, William Lewis was the business agent for the Portuguese part of the cannery. The Warehousemen, Food Processors, Drivers, and Helpers Union, which mainly consisted of Portuguese and Italian workers, negotiated healthcare and fair wages and resolved labor management disputes for the Duffy Mott, Pratt Low, and DeFury Brothers Canneries. Lewis grew up on his father's East San Jose apricot ranch, married at Five Wounds, and served as chairman for the Disabled Children's Center in Cupertino. (Courtesy Bob Lewis.)

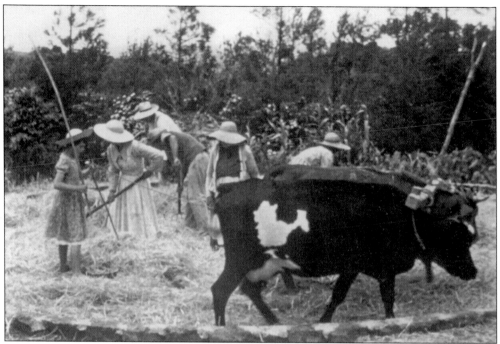

THRESHING FLOOR, FAIAL, 1959. A little girl holds a stick to prod the cows forward. The girl's weight helps hold the board on the ground as she is dragged behind the cow. The board crushes the wheat. (Courtesy AF.)

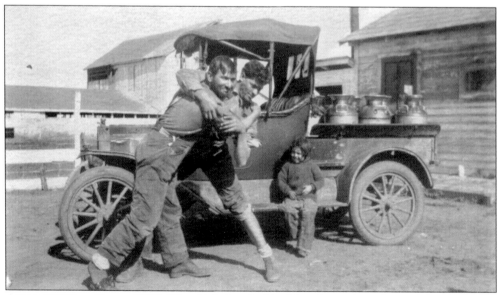

ANTONE VIEIRA SILVA, 1920. Silva (right) and a hired hand wrestle in front of the milk truck as they prepare to transport milk cans from Madera to San Jose. Little Alice Borba (Bettencourt) sits on the running board. (Courtesy MM.)

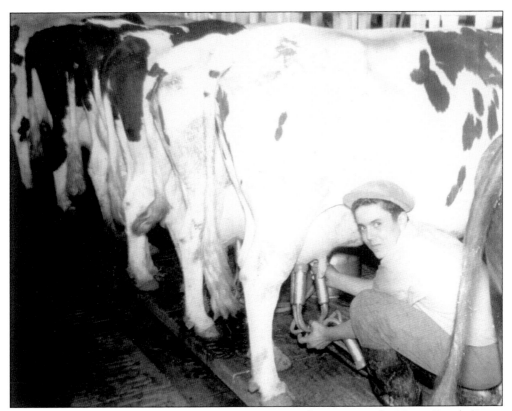

NUNES-ESTRELA DAIRY, 1954. Above, Batista Vieira milks a cow on the Nunes-Estrela Dairy. Below, Madeline Estrela (left) and Ana Vieira stand in the milking barn. Born in Sao Jorge in 1937, Batista Vieira came to the United States for economic opportunity and to fulfill his grandfather Manuel Vieira de Sequeira's wish. Manuel's friend Antonio Nunes, who owned the Nunes and Estrela Dairy, gave the 16-year-old Batista a job milking cows from 1954 to 1956. When Nunes sold the dairy in that year, Batista worked at the American Dairy with Joe Pereira and ate meals cooked by Mary Machado. (Courtesy Vieira family.)

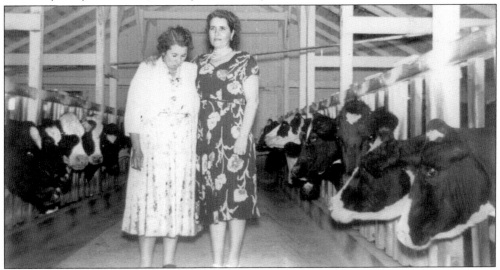

SHARECROPPING, 1920. Elizabeth and Emma Silva (third and second from the left, respectively) ride with friends on the Downing Ranch in Milpitas. About two-thirds of its farmers (15 families) lived on the Downing Ranch. Each one had a barn, a small house, a cow, and a team of horses to work the land. One-third of the profits went to the Downing family, the owner of the land, while two-thirds went to the sharecropping families. Parents often counted on their children to chip in during harvest time. (Courtesy MM.)

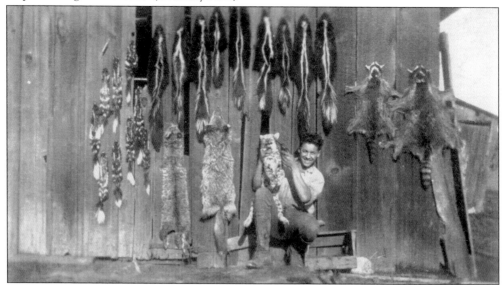

MANUEL VIEIRA SILVA. Manuel Vieira trapped animals on the Downing Ranch in Milpitas in the 1920s. At the San Jose market, he sold animal skins including that of the skunk, possum, raccoon, and bobcat. People trapped animals by digging holes in the ground and then covering the holes with grass and leaves. After hapless animals fell inside, a strong metal trap snapped around their bodies. (Courtesy MM.)

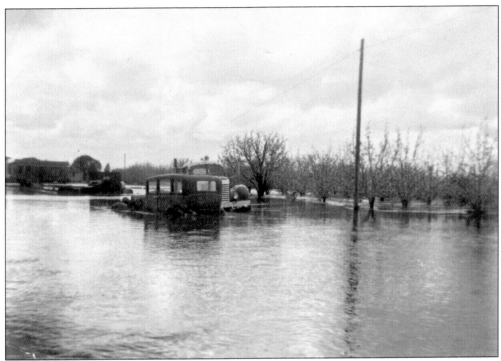

FLOODING ON FIRST STREET. As farmers tapped artesian wells and ground water, the valley subsided, with North First Street toward Trimble Road flooding. Madeline Moitozo recalls, "Water came up the house steps. I remember my brothers built a raft." In 1958, old trucks and cars on the Silva ranch were inundated. In 1956, Chuck Silva had to be rescued by boat from his house by Manuel Mello and Mac Moitozo. He lost all his farm equipment. (Courtesy Moitozo.)

FISHING IN ALVISO, C. 1930. Mac Moitozo remembers duck hunting and fishing in the Alviso Sloughs. (Courtesy Moitozo.)

MOONSHINE. During Prohibition, the Mattos family made its own spirits. (Courtesy EMLW.)

PERCY PICNIC, 1929. Shown from left to right are Ed Vargas, Harry Oliver (in back with cigarette), Ed Leal, three unidentified people, and Ruth Leal (foreground right). Ed and Ruth played the accordion and drums at Percy and Vera Cardoza's house on Fleming Avenue to celebrate Lewis Percy Cardoza's baptism. (Courtesy PV.)

Three

MARRIAGE AND THE PARISH

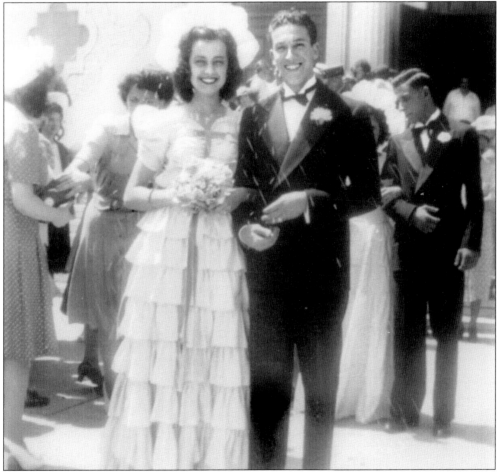

IMMIGRANT PARISH. Peggy Vargas (left) stands next to Madeline's brother, Frank Lima, beaming during the wedding of Madeline Lima and Al Mattos in 1942. Davide Vieira describes the parishioners of Five Wounds as "an immigrant parish—a parish of Portuguese, primarily Azorean, immigrants whose spiritual lives had been formed years before in a far-away place. . . . Immigrants and their first- and second-generation American born children have very different spiritual and cultural needs. And yes, in this very unique parish the spiritual and the cultural are inseparable." (Courtesy Davide Vieira and Peggy Vargas.)

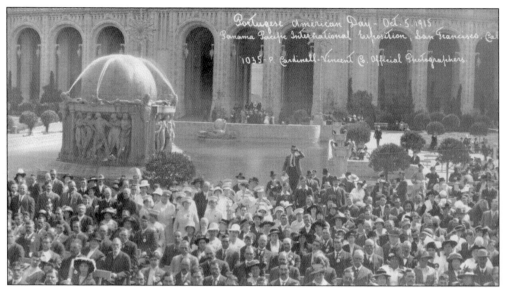

PANAMA PACIFIC INTERNATIONAL EXPOSITION, 1915. Before the San Francisco World's Fair, the Portuguese government (which had just changed from a monarchy to a republic) was not willing to finance the Portuguese Pavilion. Dr. Jose Bettencourt, Joaquim Silveira, and Francisco I. Lemos traveled to Portugal on June 15, 1914, to convince the Portuguese government to fund the exhibit. The Portuguese Pavilion was built in the Gothic style and dismantled like the rest of the fair, except for its Palace of Fine Arts. Some columns are incorporated in Joaquim Silveira's house on Mountain Boulevard in Oakland. Peggy Vargas recalls that her grandfather Antonio S. Cardoza brought the wood for Five Wounds down from the Portuguese American Exhibit at the Panama Pacific International Exhibition in San Francisco. (Courtesy JAFL.)

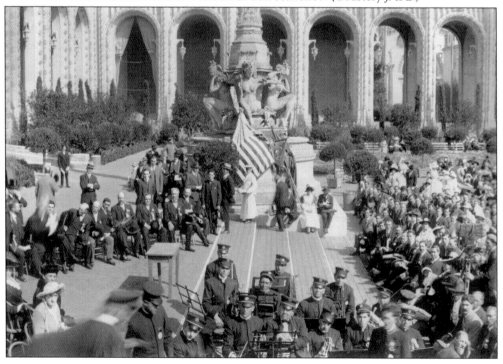

IMPERIO. The Portuguese in San Jose longed for the *imperio* (Holy Ghost chapel) of their home islands, like this one in Terceira. (Courtesy PHPC.)

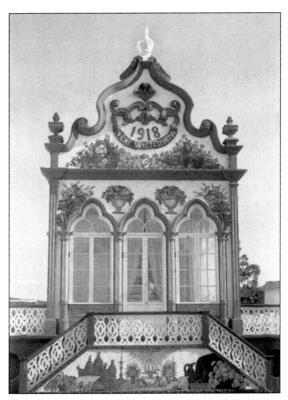

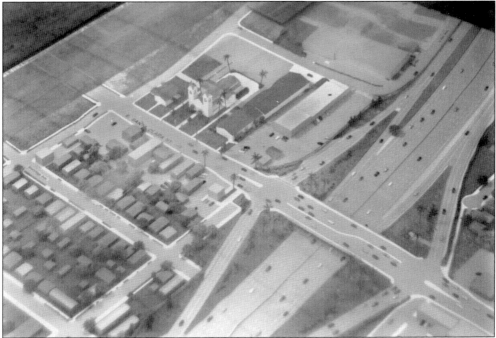

EL CAMINO REAL. This model shows the location of Five Wounds National Portuguese Church. Wood for the construction of Five Wounds Church was originally carried down El Camino Real, once an old Spanish foot trail connecting California's missions. (Courtesy RB.)

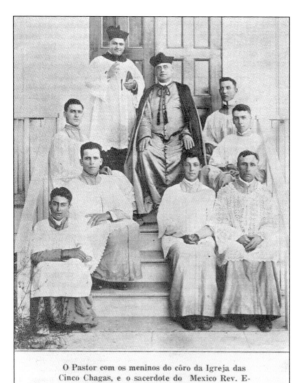

O Pastor com os meninos do côro da Igreja das Cinco Chagas, e o sacerdote do Mexico Rev. Eduardo Hilário de La Penna e Espinosa, que ultimamente tem residido na paróquia

FATHER RIBEIRO. In this early photograph, Father Ribeiro appears on the steps of Five Wounds National Portuguese Church. Born in Faial, Ribeiro was 47 years old when he settled in East San Jose in 1912. Neither his age nor his lack of fluent English kept him from fulfilling a dual dream. He knew the Azoreans were devoted to the Holy Ghost and assembled 81 men for a Holy Ghost society. He received permission from the San Francisco bishop, as well as directly from Rome. (Courtesy JAFL.)

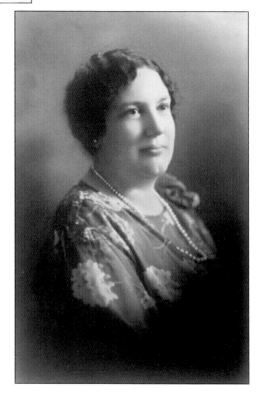

LEADER OF THE CHOIR, 1935. Mary Azevedo Alves founded the Five Wounds choir in 1919 and, for the next 50 years, served as its director and singer. In 1961, Pope John XXIII gave her an apostolic benediction for service to the Church. Her whole social life revolved around Five Wounds. In 1947, Alves made three records at Sherman and Clay Music Store on South First Street in downtown San Jose. She sang three versions of "Ave Maria"—one for each son—and on the flip side she recorded the Portuguese folk songs "Camelias" and "Saudades." (Courtesy RA.)

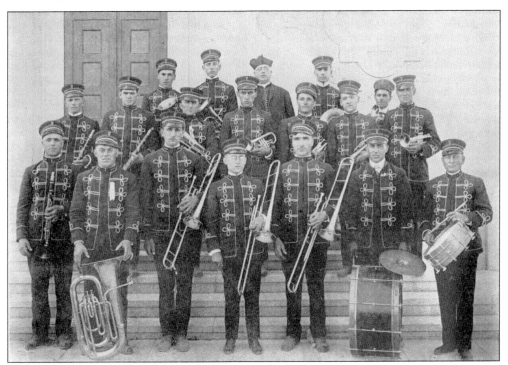

FIVE WOUNDS BAND, 1917. Founded in 1917, Conductor Spooner stands with his band. Identified band members include Henrique Bettencourt, Francisco Amaral, Francisco Rodrigues, Manuel Duarte, Jose Nunes da Rosa, Francisco Bettencourt, Jose Cardoso, Jose Oliveira, Luiz de Freitas, Paulo Avila, Joaquim Medina, Manuel Nunes da Rosa, Francisco Rosa, Manuel Silveira, Antonio Silveira, Manuel Costa, and Mr. Wood. (Courtesy JAFL.)

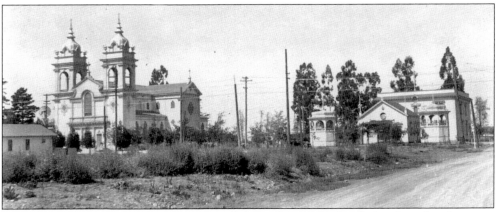

FIVE WOUNDS BEFORE HIGHWAY 101. From left to right are the church, bandstand, and imperio with the original hall behind it. The Five Wounds program *lembrança* (souvenir) mentions that Manuel Teixeira de Freitas gave $1,100 for electric lights in memory of Maria Freitas; Manuel and Mariana Alemao gave $1,533 for foundation stones and "two bells with very harmonious sounds;" F. Rosa gave $500 for the pulpit; "Antonio Machado left $500 for four beautiful angels to ornament the Altar;" Antonio Azevedo donated $500 for St. Isabel's altar; and the Brotherhood of St. Antonio offered $500 for their patron saint. The founders hoped that the church ,modeled after those in the Azores, would be visited by the Portuguese in California. (Courtesy PHPC and PV)

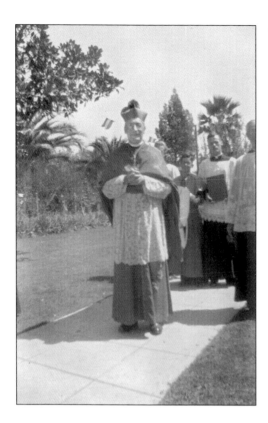

FATHER ALVES. The uncle of choir director Mary Alves, Father Alves visits Five Wounds. (Courtesy RA.)

FATHER NOIA. Fr. Leonel Noia was a charismatic (and controversial) priest at Five Wounds Church from the 1970s through the millennium. Noia left the seminary to join his family in America, declining the bishop's insistence that he go to Rome to pursue a doctorate. Davide Vieira's eulogy reads, "Fr. Noia guided the parishioners of Five Wounds in a lesson from St. James who wrote, 'Faith without good deeds is useless.' Shortly after his arrival Fr. Noia established St. Isabel's Kitchen to feed the hungry daily. . . . And in true Portuguese fashion, much of the fruit and vegetables that went into the lunch bags during the summer months came from the gardens of parishioners. . . . By his own estimate, Father Noia presided over 300 festas in his sixteen years [at Five Wounds]." Noia had studied at the Seminario de Angra, Terceira. According to Tony Goulart, his homilies and sermons brought the classics to life; he was an intelligent and charismatic speaker. (Courtesy LR.)

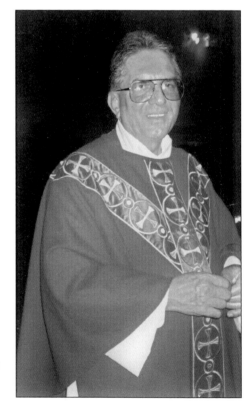

SR. MARIE IMACULADA. Frank Vargas's sister Grace Vargas was educated at Notre Dame College on Third Street in San Jose. She became Sr. Marie Imaculada of the Sisters of Notre Dame in Belmont. According to her niece Peggy Vargas, Marie was later made superior in charge of all the Notre Dame Colleges all over the world. At the time of her passing, she was starting Portuguese language departments in Catholic universities. This position led her to Coimbra, Portugal, to check on the Catholic college there. Crossing the street, she suffered a heart attack and died instantly, doing the work she loved. (Courtesy PV.)

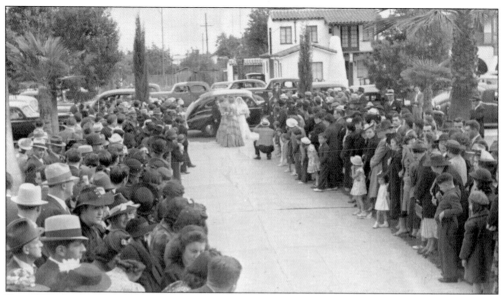

ROSE WEDDING, 1939. Madeline Moitozo married Manuel Rose at Five Wounds Church on October 1, 1939. Though it was the Depression, the bridal party went to the DeAnza Hotel for dinner and then back to the IES Hall for dancing and refreshments of ice cream and cake. (Courtesy Moitozo.)

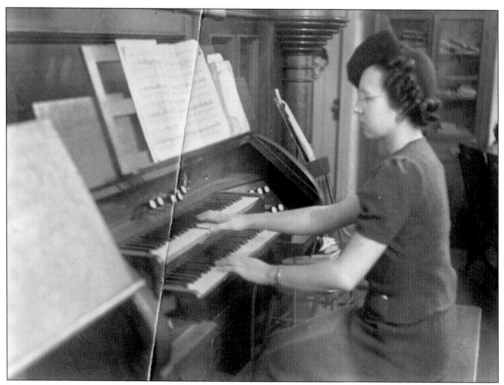

LUCILLE MACHADO PLAYS THE ORGAN. Raised by her widowed mother, Lucille Machado attended San Jose State Teacher's College and then played for Five Wounds for many years. (Courtesy Madeline Rose.)

LIMA WEDDING. Peggy Vargas got her friend Madeline Lima together with Al Mattos when Mr. Lima would not let his daughter go out on dates. Peggy fixed it for the senior ball as Madeline's chaperone. Coming from the dance, the bottom of Madeline's dress became covered in mud (which suggested a fallen woman); Peggy cleaned the dress before taking her friend home. (Courtesy PV.)

MERIDIER-ALVES WEDDING, 1968. Fr. Charles Macedo performed the wedding ceremony for Clare Meridier and Jose Alves at Five Wounds Church. While in seminary, the priest had been entertained by Clare Alves's in-laws, Gil and Anna Maria Alves, in San Miguel, Azores. Clare became historian emeritus in San Diego and currently serves on the Portuguese Museum Board of Directors. (Courtesy CA.)

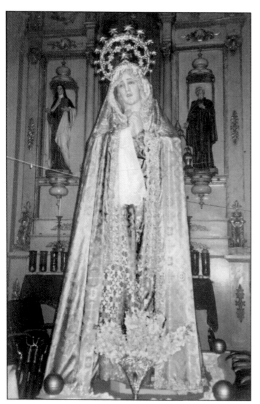

OUR LADY OF FATIMA. Our Lady is believed to have appeared six times to three children in Fatima, Portugal, in 1917. Francisco and Jacinta died soon after the experience, but Lucy lived on and joined a Carmelite order as Sr. Mary Lucy of the Sorrows. Devotion to Our Lady of Fatima is evident at Five Wounds Church; her blue statue is striking. (Courtesy LR.)

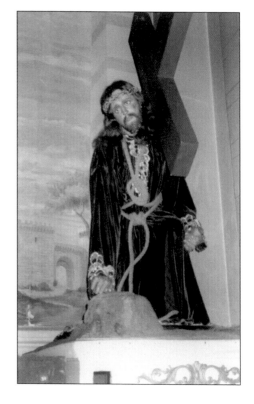

CHRIST WITH FIVE WOUNDS. This statue is one of five depicting Christ's wounds that are carried through the San Jose streets to the beat of a slow drum. Parishioners participate while many onlookers seem moved by the mournful procession. (Courtesy LR.)

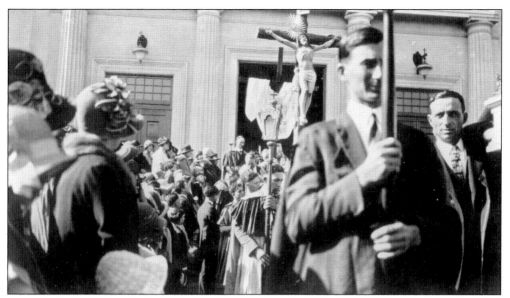

PASSION SUNDAY PROCESSION, APRIL 1926. To this day, the ancient tradition of the Passion Play continues in San Jose Five Wounds Church. Portuguese parishioners bear statues of Christ's five wounds around the city block and up the church steps. The sights of the sorrowful and wounded statues amid purple drapes, along with the sounds of the deep drum beats, take marching participants back in time. (Courtesy Vieira family.)

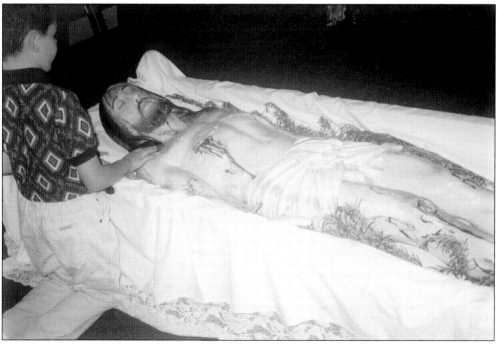

BOY AND WOUNDED CHRIST. San Jose artist Lynn Rogers captures the solemn encounter of a young boy contemplating the wounded Christ in Five Wounds. (Courtesy LR.)

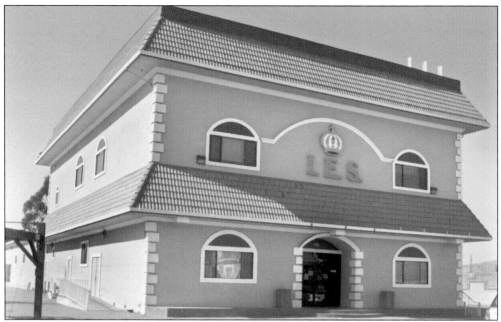

IES HALL. Today's rebuilt IES Hall celebrates the society's rich history. Father Noia once read Monsignor Ribeiro's diary to learn that the IES was established with "remnants of an earlier 'Irmandade Velha of Alviso Road.'" Manuel Teixeira de Freitas loaned a generous sum of money for the acquisition of property on Twenty-eighth and Thirtieth Streets, where a chapel for the Holy Ghost was built. (Courtesy RB.)

DOM DINIS PRESCHOOL. In 1983, Goretti Silveira founded Jardim Infantil Dom Dinis Preschool in what once was the Five Wounds Convent. Silveira also taught Portuguese language and culture at San Jose High School and English as a second language from 1976 to 1993. At Dom Dinis, all children (Portuguese, Filipino, Chinese, Anglo-Saxon, Vietnamese, Spanish, Mexican, South American, and East Indian) learn two Portuguese songs: "Amizade" and "Atirei om pau ao gato." The kindergarten children reflect the mixing of cultures. (Courtesy GS.)

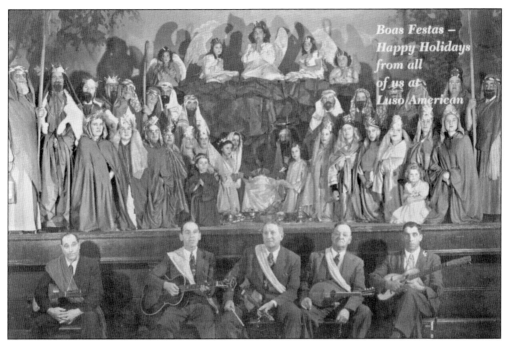

Boas Festas —
Happy Holidays
from all
of us at
Luso American

NATIVITY PLAY, 1946. This picture was taken at the old IES Hall by San Jose Council 47B. The angels atop the manger are, from left to right, Antoinette Machado, Mary Cardoza, Barbara Silva, and Dolores Machado. The Bettencourt family stands near their baby (Jesus); live sheep also participated in the play. In 1992, the Vieiras were eating dinner when they saw flames rise up near Five Wounds. Streets were blocked, and many watched the news in horror as the IES Hall burned. About nine months later, they had raised enough money to rebuild it. (Courtesy Luso-American, through the Vieira family.)

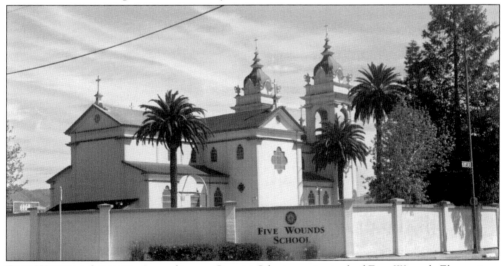

FIVE WOUNDS SCHOOL. According to Goretti Silveira, principal of Five Wounds Elementary Catholic School from 1993 to 1997, the Portuguese language was once taught by nuns learning English—but not today. With a capacity of 350 pupils, the private kindergarten–eighth grade school includes a rigorous preparatory curriculum and employs secular, credentialed teachers to instruct students of all faiths. (Courtesy GS.)

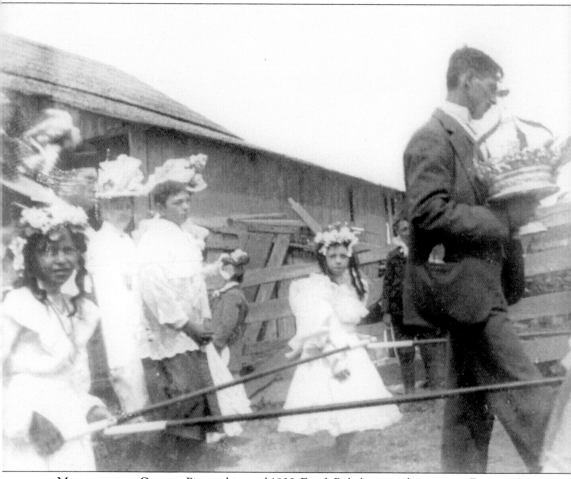

MEN WITH THE CROWN. Pictured around 1900, Frank Baliel carries the crown in Freeport. Maria Carty's article in the Portuguese Heritage Publications' *Holy Ghost Festas: A Historic Perspective of the Portuguese in California* states that, from 1694 to 1714, the bishop in the Azores forbade women to be crowned in the Holy Ghost Festa; men or boys always carried the crown. Carty states that, by 1894, the Church had passed an edict allowing young ladies up to age 10 to be crowned. Once in America, the tradition of the maypole parade blended with the queen of the Holy Ghost Festa, and even secular Portuguese societies celebrated the queen. Isabel is pictured here in simple clothes and simple garland on her head. Carty asserts that while the Azores had religious processions, the California Azoreans held parades that combine religious and secular motifs. (Courtesy PHPC, *Holy Ghost Festas.*)

Four

FESTA AND FAMILY

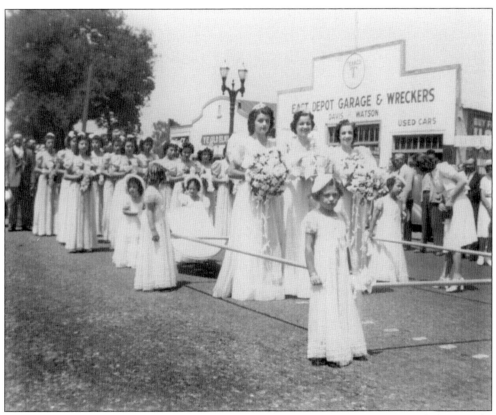

HOLY GHOST FESTA QUEEN, 1940. Queen Edith Mattos (center) marches with her maids, Margaret Rose (left) and Madeline Lima. This Holy Ghost Festa took place on June 29 and June 30 at the IES Hall and Five Wounds Church in East San Jose. Saturday included the queen's introduction followed by singing, dancing, fireworks, and a carnival. Sunday morning brought the crowning, a procession with the queen and her maids, then High Mass and *sopa* and *carne* for everyone. (Courtesy MC.)

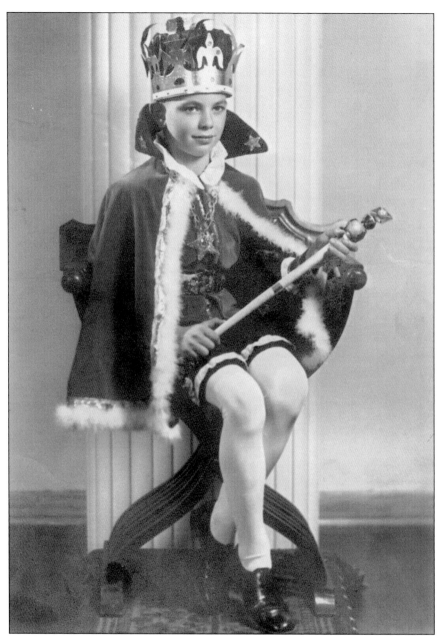

KING TONY, 1938. Anthony Moitozo played his namesake in the St. Anthony Festa at Five Wounds Church. When not at church or in school, Moitozo worked on the family pear orchard or on another orchard up the street. Many young people worked 10 hours a day on their parents' ranches. Mac Moitozo recalls, "We drove tractors, horses, whatever had to be done. Eight, nine and ten-year-olds drove cars in those days, there was no traffic. . . . There was no such thing as staying overnight [with a friend]. I was 15 before I stayed away from home. Today we're pretty much blended with American culture. But then, people worked, didn't play around much. My dad had people working for him who came from the Azores. They worked on the Moitozo ranch for $50 a month. [A car then cost $700.] Many of those people are now millionaires." (Courtesy Alice Moitozo.)

QUEEN FOR A DAY, 1931. Edith Mattos's family held the Holy Ghost Festa crown for a week. Her father, Manuel, had built an altar in the corner of the living room to honor Queen Isabel. Here pictured at age eight, Edith stole the crown and played dress up, pretending to be the queen. Turns out it was a dress rehearsal for the real thing; Edith was crowned queen of SES in 1938 and Irmandande do Espirito Santo (IDES) do East San Jose in 1940. (Courtesy EMLW.)

LITTLE PRIEST, 1962. Little Davide Vieira wears a priest's habit while marching in the IES Festa on the last Sunday of June in 1962. Two St. Anthonys and a little nun accompany Davide Vieira, who stands in front. (Courtesy Vieira family.)

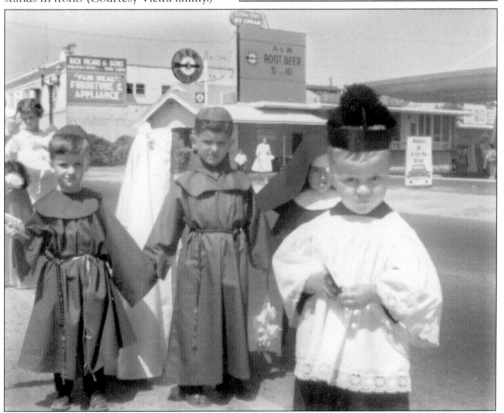

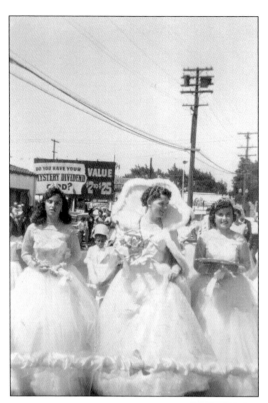

A QUEEN AND HER MAIDS, 1957. Queen Lynette Held and side maids Beverly Kampfen (left) and Dolores Machado (right) walk from the IES Hall to Thirty-fourth Street on their way to Five Wounds National Portuguese Church. The Holy Ghost Festa goes back over 600 years to when Queen Isabel won a battle in Alvalade. Fresh from her victory, she vowed to remember the blessings of the Holy Ghost each year by holding an annual festival in which the poor would be fed free of charge. The queen of the festa is the human embodiment of this spirit of generosity, and her procession leads the crowd to a festival where *sopa* and *carne* are free for all who wish to partake. (Courtesy Vieira family.)

HOLY GHOST FESTA QUEEN MADELINE ROSE. In 1937, Madeline borrowed the crown from another queen, returning it after the festivities. During the Depression, the $200 cost of the crown was beyond the means of the family. Pictured here, from left to right, are ? Rose, Alice Rose (Avila), Madeline Rose, Amy Silva (Arsenio), and Manuel Moitozo. Amy Silva became a schoolteacher and principal in San Luis Obispo. (Courtesy Madeline Rose.)

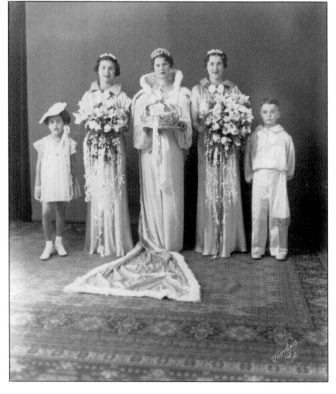

QUEEN MATTOS. Queen Edith Mattos (center) marches with her maids, Margaret Rose (left) and Madeline Lima. (Courtesy Vieira family.)

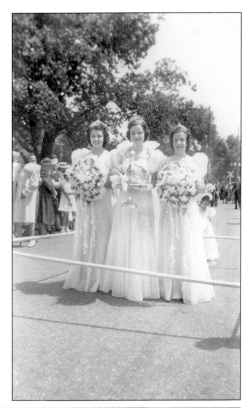

ALLIANÇA JORGENSE HOLY GHOST FESTA. The Alliança Jorgense was created in 1978 to celebrate the Holy Ghost Festa as it was performed in the Azores. (Courtesy PHPC.)

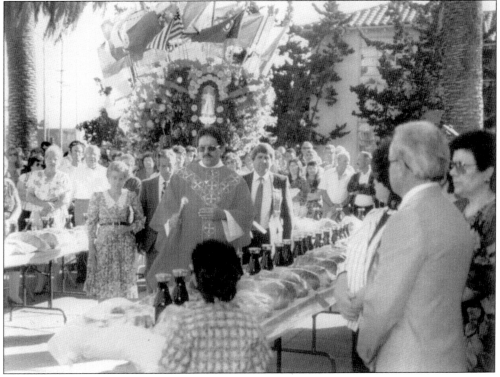

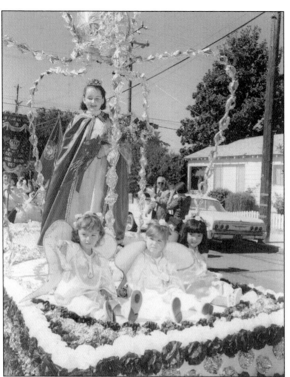

HOLY GHOST FESTA, OAKDALE. The girl in the center, representing St. Isabel, wears a simple cloak and tiny crown. She is shrouded in the Holy Ghost, and precious angels are at her feet. (Courtesy MC and PHPC.)

IES QUEEN 50TH ANNIVERSARY, 1965. Maria Salome Cunha (Wong) (left), queen Maria de Fatima Cunha (Terra) (center), and Maria Ascensao Cunha (Carty) are shown in the chapel at the IES. St. Anthony appears on the left and Our Lady of Fatima on the right. (Courtesy MC and PHPC.)

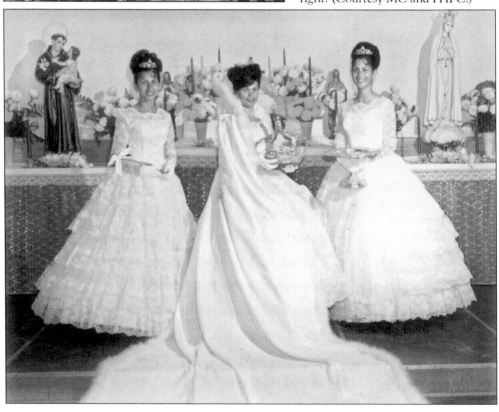

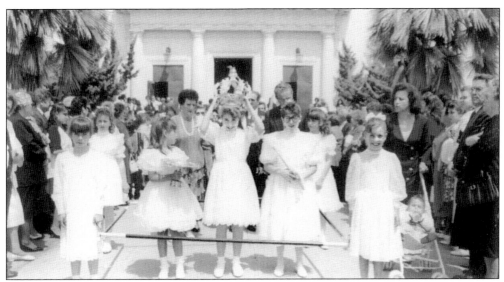

HOLY GHOST FESTA, 1980. This charming photograph shows the longevity of the San Jose Festa tradition. A little queen holds a crown over her head in the same manner as Queen Isabel of hundreds of years ago. (Courtesy MC.)

MODERN ROSQUILHAS. Lucia Goulart carries a large sweet bread in the shape of a ring on her head. In this procession, women walk barefoot with a terrycloth head covering made into a circle, supporting both bread and flowers. According to Maria Cunha Carty's article, the Rosquilhas procession was created in 1990; the bread is a *promessa*—an offering to the Holy Spirit. This tradition goes back to the Azores, where people would give up their food so that God would help someone in their family who was sick or in need. The key element in the Rosquilhas ceremony is to sacrifice something essential in order to receive a blessing. (Courtesy MC and PHPC.)

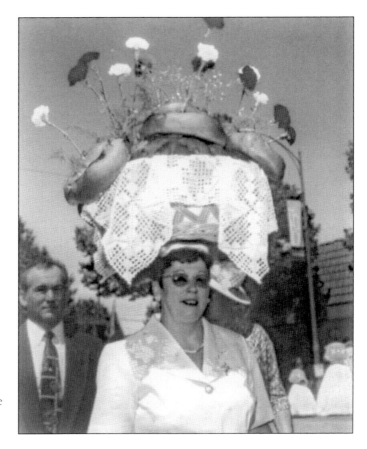

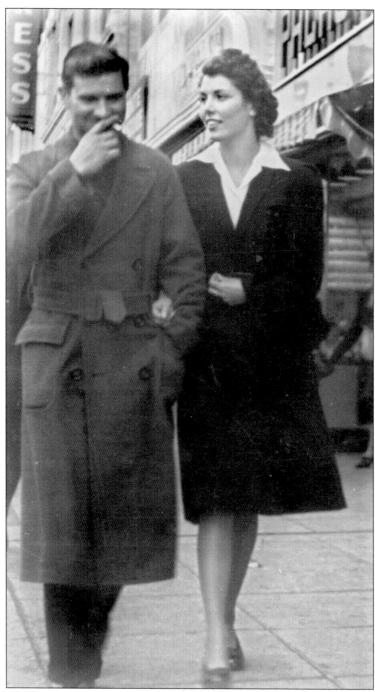

DOWNTOWN SAN JOSE, 1940. Ernie Vargas and his future wife, Isabel Maciel, walk down First Street in December 1940. In 1941, Ernie and Isabel became engaged on Valentines Day but waited until Easter to announce it because Isabel's first cousin Eugene was in O'Connor Sanitarium with pneumonia and soon passed away. The couple bought wedding rings at Royce Jewelers, 72 South First Street, in April 1941. Because the rings were designed for someone else, they got a good deal on them. In the background is Kress's 5 and 10. (Courtesy SV.)

Five

HOME FRONT

JOE MATTOS (RIGHT) AND BUDDY. In 1939, Joe enlisted in the armed forces to fight Hitler. He became a staff sergeant at Hickam Field in Oahu. Edith Mattos received a cryptic phone call from her girlfriend Margaret Vargas at Western Union—a Western Union telegram read, "Your son Manuel Mattos was drowned at Yachats, Oregon." It was right after the bombing of Pearl Harbor, and immediately Edith thought of her brother Joe, who the family feared was also dead. It would be another two weeks before the family learned that Joe was alive. He had left Pearl Harbor on December 6th, the day before the bombing by the Japanese. (Courtesy MM.)

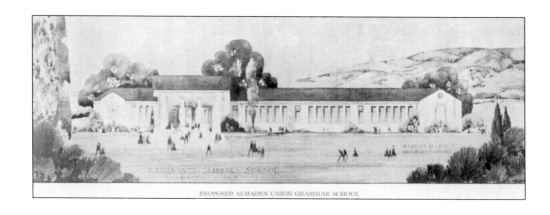

PROPOSED ALMADEN UNION GRAMMAR SCHOOL

NEW ALMADEN SCHOOL, 1926. These images feature the proposed Almaden Union Grammar School (above) and the class of 1926 (below). Included below are the following, in no particular order: Lasich Louis Fagaide, Fortunado Mancusso, Joe Manzone, Sipriano Barron, Sirel Cecala, Raymond Ogan, Richard Matteis, Rose Curei, Josephine Malvini, Stella Bianco, Elizabeth Feihman, Dorothy Rose, Clara Athenour, Lucille Janich, Alexander Hernandez, Mr. Kennedy, and Joe Carlo. The Almaden Union School used to have annual picnics at Alum Rock Park, where there was a swimming pool, slides, and a small petting zoo. (Courtesy DC.)

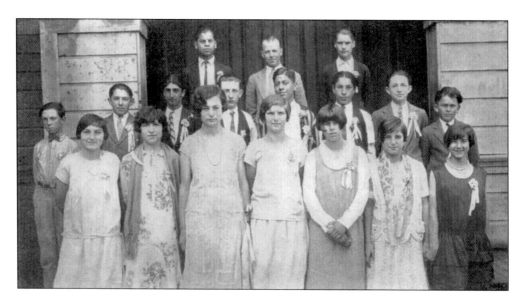

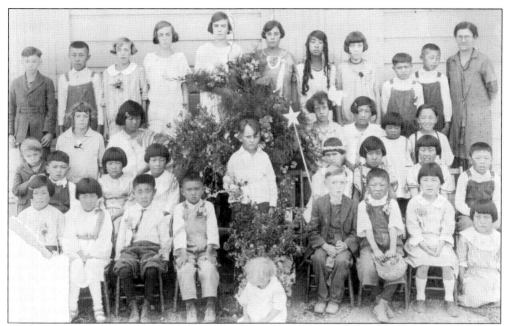

CHRISTMAS PLAY, 1925. Among those identified include a six-year-old Madeline Moitozo, holding the star in the Midway School production written and composed by teacher Edna Ridley (top far right). At first, the school near the Moitozo Ranch consisted of two rooms for students in the first to eighth grades, with Miss Passetta helping. According to Anthony Moitozo, his teacher was "a little bitty thing. Mrs. Ridley sometimes brought her [disabled] daughter Berta [who] seemed happy-go-lucky though quiet." Later the school was just one room in which the beloved Mrs. Ridley taught everyone. (Courtesy Moitozo.)

PETER BURNETT JUNIOR HIGH SCHOOL, 1932. This school is located on the north side of San Jose. Included here are the following: (first row, from left to right) Leonard Salamande, Marjorie Ellison, Virginia Chavez, Marian Ellison, Betty Germons, and Charles Taylor; Harold McCall; Seige Kawashima; and Anthony J. Lewis (middle of the back row). (Courtesy EMLW.)

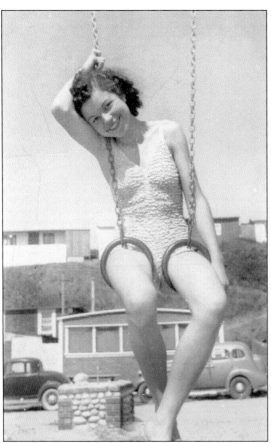

EDITH ON THE BEACH. Edith Mattos plays on a beach swing. She was a blithe spirit then and is equally so now as an octogenarian docent and historian for the Portuguese in San Jose. (Courtesy EMLW.)

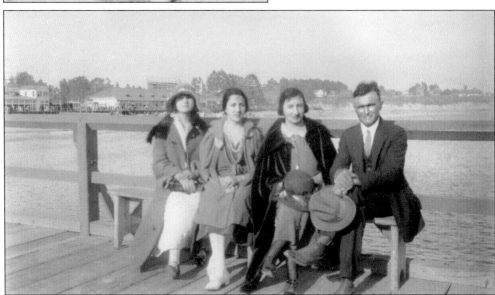

A DAY AT THE OCEAN, 1926. Family friends (left) join Joseph and Mary Machado for a day near the sea at Santa Cruz. The Machados went over pretty often to remember the Azores. Behind them are the rides of the beach boardwalk, including the Big Dipper. (Courtesy Dolores Vieira.)

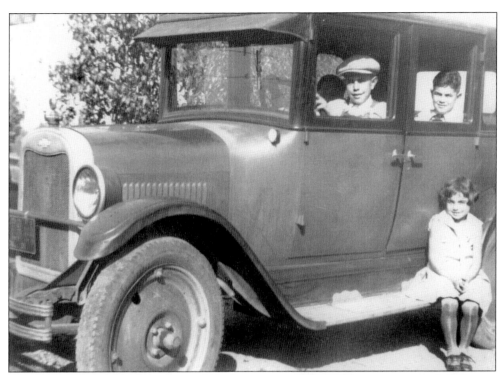

OFF TO SANTA CRUZ, 1929. Above, Alfred Mattos sits at the steering wheel, with Manuel Mattos Jr. behind him. Little Edith Mattos perches on the running board. After a hard season picking prunes, the family is dressed for a vacation in Santa Cruz (right). They rented a motel room for $15 a night. The Mattos parents slept in the bedroom, Edith on the floor, and the boys outside—Joseph and Manuel Jr. under the car and Henry in it. Money was tight, but everyone was happy. The men fished for dinner at the Santa Cruz wharf; the women brought canned goods and fresh bread from San Jose. Edith remembers that her mother, Rose, had packed the car's trunk so full that the canned fruit and boxes could not make it over Highway 17. The family had to stash them at the summit. Returning from their week-long vacation, the Mattos family was surprised to see that someone, probably a hobo, had stolen all their food. (Courtesy EMLW.)

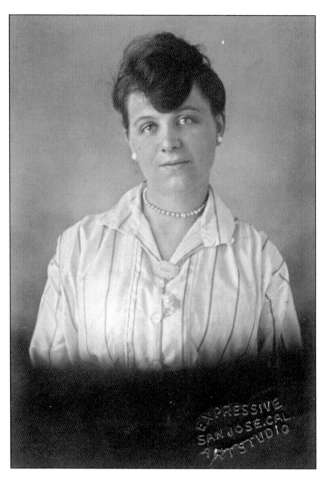

ANNIE BORBA, 1918. Rumor has it that Frank Borba shot someone in San Francisco in the 1930s, and his sister Annie took the blame in order to spare Frank a prison sentence. In 1963, Annie's other brother, Gus Borba, thought he killed Marian Reinhard, the neighbor with whom he was having an affair. As a result, he turned the gun on himself. (Courtesy MM.)

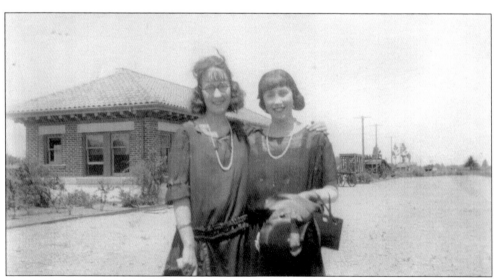

AT THE STATION, 1923. Elizabeth Vieira Silva (left) of San Jose poses with a friend. She married Joseph De Gregory, also of San Jose, who created machinery to pit pears and peaches. (Courtesy MM.)

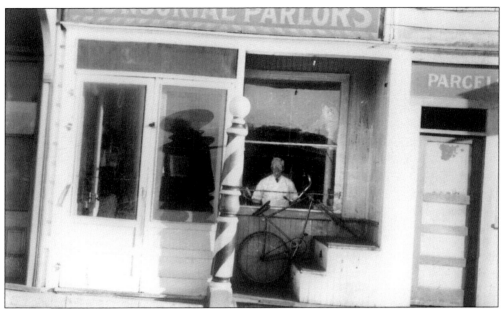

SHAVE AND A HAIRCUT, 1910. John Alves stands in front of his barbershop (above), located on Basset Street off First and Market Streets across from the old Southern Pacific Railroad depot. Alves rode his bicycle there every day between 1910 and 1960. On layovers, train passengers crossed the street and paid six bits (75¢) for a shave and haircut from Alves or his partner, Antonio Faria (right). (Courtesy RA.)

ASSOCIATED GAS STATION, 1935. Edwin Alves worked at the Associated Gas Station on Auzerais Street in San Jose. At 21, he was a talented saxophone player who went around the world in 30 days with his five-piece band. The group traveled on the SS *Hoover* playing exotic lands including Egypt and Lisbon. (Courtesy RA.)

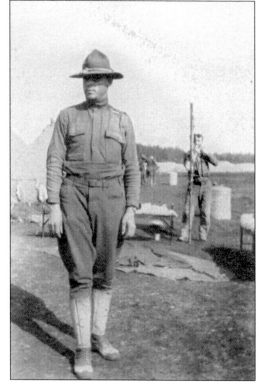

WORLD WAR I SOLDIER. Joseph Vieira Silva stands ready to serve his country in 1916. A fellow soldier appears behind him, shaving. Joseph Silva received the Purple Heart after a brush with death. The doctors gave Joseph the bullet that shot him as a souvenir. He miraculously recovered and returned to San Jose, where he worked for Larson Ladder. (Courtesy MM.)

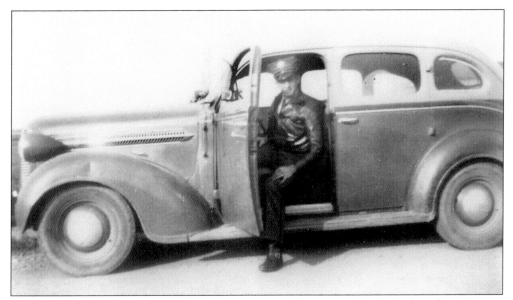

TONY SANTOS AND SQUAD CAR, 1959. Born into a Portuguese family hailing from Hawaii, Santos was remembered in Alviso atop his tractor, excavating earth. His fiery initiative later made him police chief, mayor, and owner of a significant amount of land. He sold migrant workers plots for $5. His son Dick, a past fire captain, now serves as a water district board member and helps with the Santa Claus program for disadvantaged children. His other son Al is a contractor. (Courtesy DS.)

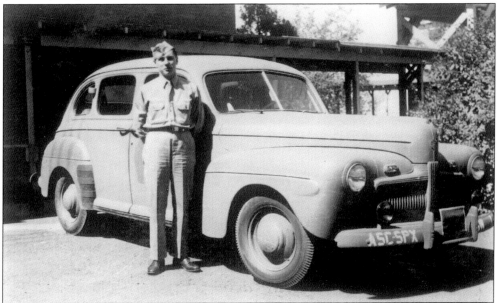

PVT. RICHARD ALVES, 1943. At age 20, Alves stands in front of the house on North Seventeenth Street by his first car, a 1936 Dodge four-door sedan. His service took him first to Monterey, then to Jefferson Barracks outside of St. Louis, Missouri, and on to Spokane. Alves went there in the dead of winter and contracted rheumatic fever. He later became the base sergeant major at Fort George Wright Station in Spokane. In 1943, he came home on medical leave and got engaged; he married in January 1944. (Courtesy Richard Alves.)

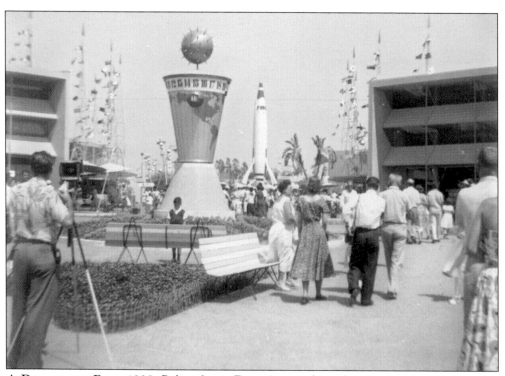

A DAY AT THE FAIR, 1939. Below, Louis Figone's accordion players—Frank Palermo (left), Dorothy Bioccihi (center), and Ralph Ramono—sit by the Fountain of Western Waters at the Golden Gate Exposition in their band uniforms of white slacks and gold blouses, enjoying the fair after their set. Visitors were awed by giant plaster sculptures of sea gods, whales, and large pyramids. The most miraculous part of the exhibit was Treasure Island itself. A manmade island constructed by Federal Works employees, Treasure Island was reputed to have gold in its soil because it was composed of mud dredged from the Sacramento Delta River. The Golden Gate Exposition of 1939 was a brief moment of respite, a calm between two storms: the Great Depression and World War II. In 1940, the 80-foot monument to Pacifica, the goddess of the Pacific Ocean and peace, was torn down and a military base for young boys shipping out to war was put up in its place. (Courtesy EMLW.)

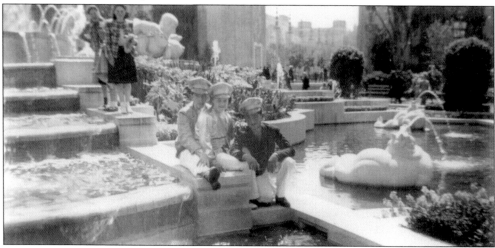

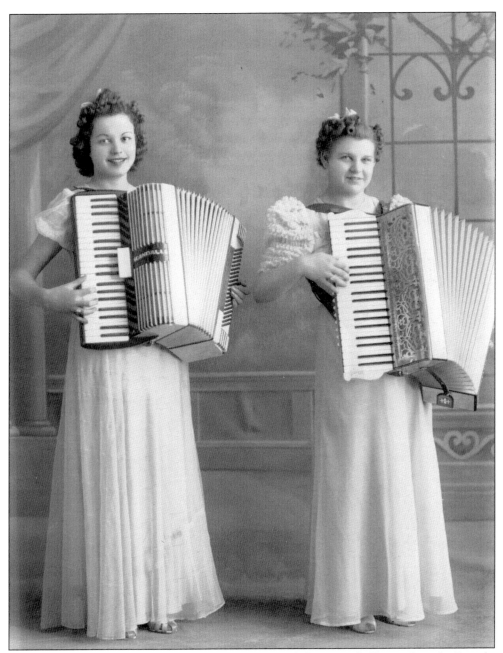

TWO ACCORDION PLAYERS, 1938. Above, 14-year-old Edith Mattos (left) joins Dorothy Brocchi in Louis Figone's accordion band. In an era when domestic responsibilities were a woman's lot, music was an avenue of personal creative expression. Edith plays "Lady of Spain" and "Beer Barreled Polka" on a Scandelli accordion. The World's Fair of 1939 (Golden Gate International Exposition) commemorated the completion of the Golden Gate and Bay Bridges. Many notable performers entertained, including Judy Garland and Sally Rand (with a feather dance). The fair's entrance featured an 80-foot statue of the sea goddess Pacifica by sculptor Ralph Stackpole. The fair's purpose was to attract visitors to the San Francisco Bay and celebrate the diversity of Pacific cultures. (Courtesy EMLW.)

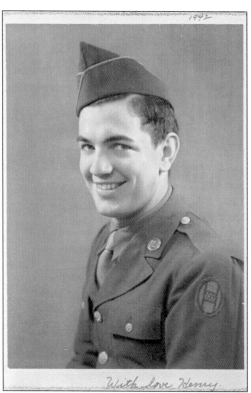

DRAFTED, 1942. A frightened 21-year-old Henry Lawrence Mattos signed his 8-by-10 glossy, "With love Henry." Like many Americans, San Jose Portuguese did not know the scope of the war, or the extent of the Holocaust. Henry fought in the second wave at Normandy. To this day, he refuses to speak about his experiences "over there." Henry's sister Edith also joined the war effort, working nine hours a day at Hendy's Ironworks, which manufactured ship turbines; she worked another four hours each night at Chevy Chase Cannery, canning fruit for the boys overseas. (Courtesy EMLW.)

TONY LEWIS'S BATTALION. This photograph shows the military induction of Portuguese boys from San Jose such as Tony Lewis (first row, eighth from left). (Courtesy EMLW.)

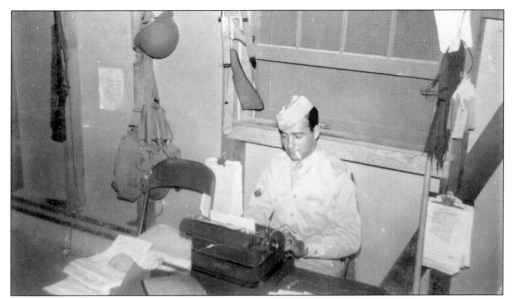

VICTORY LETTERS, 1941. Joseph Lewis sits at his barrack desk writing victory letters home. For national security reasons, all the strategy and troop movement details were carefully edited out of the "victory letters." Manuel was a fast typist; he served as secretary for Victor Handson in Hawaii before shipping off to Canton Island in the South Pacific. (Courtesy EMLW.)

FMC TANKS. During the summer of 1962, Dick Carlo worked at Food Machinery and Chemical Corporation (FMC) on the tank parts deburring machine. His job was to smooth the tank treads, which were rough when they came out of the molds. Dick's father, J. Richard Carlo, served as the supervisor of cost accounting and had gotten him the job. (Courtesy DC.)

MABEL MATTOS. During the 1940s, Mabel Mattos visited her uncle Mathew Silva's rented cabin. She came there after her hard "victory shifts" at Bayside Cannery in Alviso. Mabel remembers getting on the bus in San Jose with other Portuguese workers. "All the canneries were working full blast for the war," she says. At night, she saw sparks from Liberty ship welders across the slough. (Courtesy MM.)

RICHARD ALVES HOUSE. Seen here is the Alves family house, situated on North Seventeenth Street. (Courtesy RA.)

GRANT GRAMMAR SCHOOL, 1937. This elementary school stood at Empire and Tenth Streets in the mixed neighborhood of northeast San Jose, which included Italian, Chinese, and African American ethnicities. All the kids got along and played with each other; there was no segregation at their grammar school. Richard Alves stands in the first row, far right. (Courtesy RA.)

WALKING IN DOWNTOWN SAN JOSE. Peggy (right) and Margaret Cardoza Vargas (left) are pictured on First Street in downtown San Jose after the war. Margaret, who had been the first queen of IES, stops with Peggy for a soda at a creamery after window-shopping downtown. (Courtesy PV.)

NEW HOUSE AND NEW HOPES. Like many Americans hopeful after the end of the war, the Mattos family men build their new house. (Courtesy EMLW.)

ST. PATRICK'S SCHOOL, 1955. About 49 students were taught in this one-room schoolhouse. Many Portuguese parents sent their children to the Catholic school because of its emphasis on discipline and its religious course requirements. (Courtesy DC.)

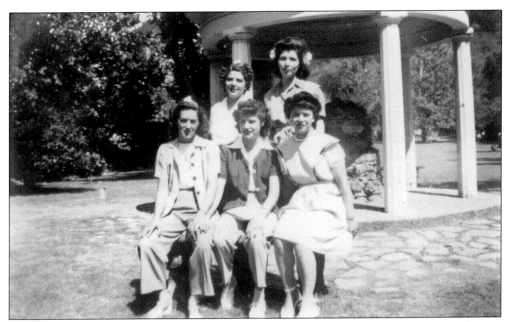

SOUZA'S SPRSI BARBECUE, ALUM ROCK PARK, 1944. Shown here, from left to right, are Margie Sarmento, Mayme Bernard, Theresa Bernard Sarmento, Anita De Valle, and Isabel Maciel (Vargas). The temple behind them is where the UPEC band sometimes sat and played. The SPRSI (Sociaded Portuguese Reigna St. Isabel, the St. Isabel Portuguese Society for Women) held dances at a church hall. The society provided members with a source of social interaction and a life insurance policy to cover funeral expenses. (Courtesy SV.)

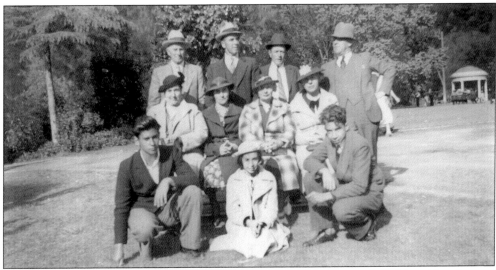

ALUM ROCK PARK, 1938. Those identified include Al Mattos (first row, left), Mary Alves (second row, left), and John Alves (third row, left). Alum Rock Park was the place to go on Saturdays or on Sundays after church on the trolley line from downtown. A visit to the gigantic indoor pool, with its 10-foot slide, cost 25¢. People bottled water from the sulfur spring to maintain good health—an old tradition from the Azores. According to Joe Machado, in the late 1920s Alum Rock Park had an anti-Portuguese sentiment, posting a placard stating "No Portuguese Allowed." (Courtesy RA.)

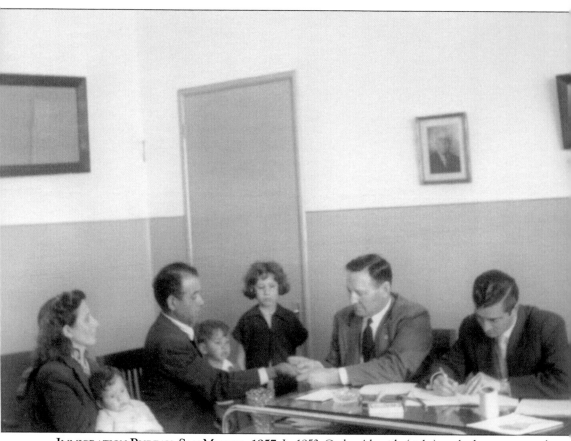

IMMIGRATION BUREAU, SAN MIGUEL, 1957. In 1953, Carlos Almeida (right) worked as a personnel manager for the Canadian National Railway, checking immigrants' calloused hands to see if they were experienced with hard labor (masonry, carpentry, farm work). People tried to pretend they had worked hard: merchants hammered their hands; sales people and cashiers put dirt on them. Almeida relates that, for 200 years, Azoreans shipped out to parts unknown. Now the tides have shifted; the Azores are the destination, not the point of departure. Almeida believes people want the quiet lifestyle today—just the sea and a tight-knit community. With good airports, it is easy to get off the islands. In the 1940s, they were very isolated, as communication was slow and one could only get off the island twice a month. Almeida recalls seeing a boat coming in and rushing to the craft's bookstore for his comics in the 1940s. (Courtesy Carlos Almeida.)

CAPELINHOS AND THE THIRD WAVE

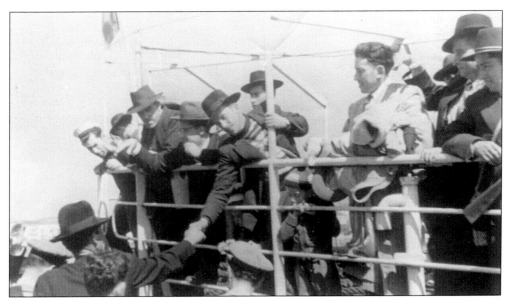

EMIGRANTS LEAVE FAIAL. In 1953–1954, Azorean law required emigrants to have at least a third-grade diploma, no criminal record, and no tuberculosis, with a full physical on the Portuguese (Azorean) and Canadian sides. When Carlos Almeida worked in the Azorean Emigration Department in Ponta Delgada on San Miguel, the reasons for Azorean emigration were simple: the lack of jobs and opportunities for Azorean children. Today the Azores are a popular destination for emigrants from countries in Eastern Europe such as Poland, Ukraine, and Hungary. These immigrants do not have to face the challenges that greeted the Azoreans in the United States in the 19th and early 20th centuries. Upon arrival, the Eastern Europeans are given language assistance and help establishing their own organizations to preserve their culture in the Azores, where the immigrant experience has come full circle. (Courtesy Carlos Ameida.)

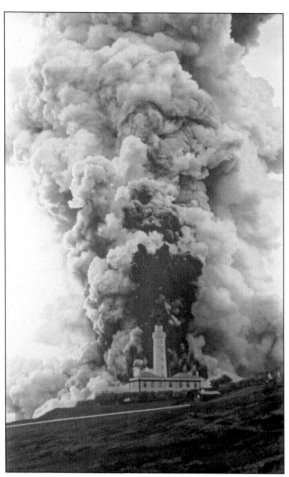

CAPELINHOS, 1957. The map below shows Capelinhos's location in the archipelago. At left, the smoke of Capelinhos engulfs a lighthouse. At night, fire and gases erupted, and the ashes made fields and houses uninhabitable for years. Villagers did not have the money to rebuild or excavate their homes; many took advantage of Sen. John F. Kennedy's special visa for 1,500 families affected by the volcano. (Courtesy AF.)

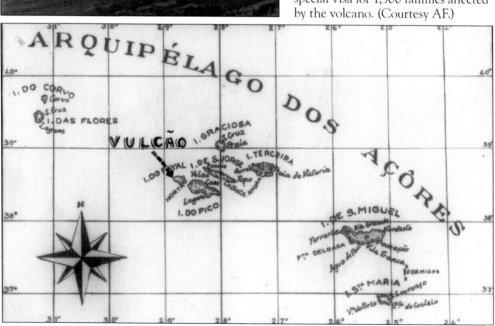

FAIAL VOLCANIC ERUPTIONS, 1957. At left is the poster for Antonio Furtado's film; below, collapsed houses reveal the destructive capabilities of Capelinhos. In 1957, Antonio Da Rosa Furtado traveled back to Faial, bringing along movie camera to film family. During his stay, an earthquake shook the islands and the volcano, Capelinhos, erupted. Grabbing his eight-millimeter camera, he captured the devastation on film in *Fayal Volcanic Eruptions*. Ashes covered the island, houses were destroyed, and Faial residents made feeble efforts to pull remnants from the ruins. (Courtesy AF.)

PORTUGUESE FILMS

(ONE SHOWING ONLY)

FAYAL VOLCANIC ERUPTIONS

IN COLOR

Narrated in Portuguese and English

The History of Fayal, Island of Volcanos and Earthquakes.

CINDERS and LAVA

Club Recreio Madeirense

178 Elm St. CAMBRIDGE

Sunday Jan. 25, at 2 P.M.

SEE

The most complete and authentic FILM, taken during actual eruptions

Produced in the Azores!

The Great FAYAL Tragedy!

Gigantic balls of Fire!

The exceptional and precise description of a VOLCANO in action!

It's horrible consequences!

A Film that will make you Think! And wonder!

A FILM YOU WILL **NEVER FORGET!**

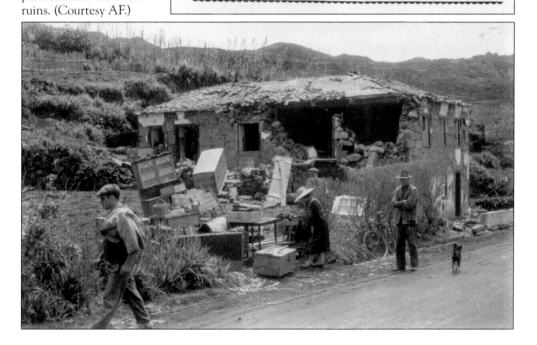

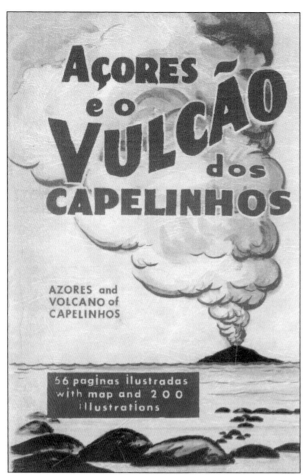

AÇORES e o VULCÃO dos CAPELINHOS

AZORES and
VOLCANO of
CAPELINHOS

66 paginas ilustradas
with map and 200
illustrations

VULCAO DOS CAPELINHOS, 1957. Antonio Furtado made a small book documenting the destruction of Capelinhos entitled *Açores e o Vulcao dos Capelinhos* (right). Furtado worked for the Massachusetts-based Comissao Pro Sinistrados, which sold his book to raise funds and awareness for volcano victims (below). Repair money, food, and eight tons of clothing were sent by boat to Faial. (Above courtesy AF; below courtesy Carlos Almeida.)

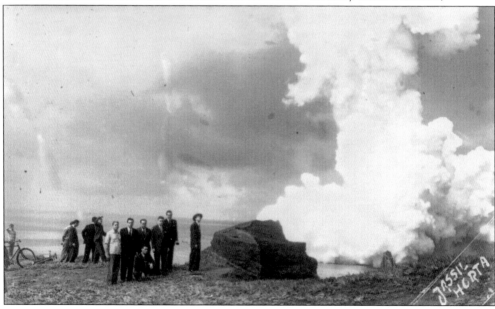

KENNEDY-PASTORE RELIEF BILL. In 1924, the Immigration and Naturalization Service enacted a quota system for Portugal, allowing only 440 immigrants, 95 percent of which could come from the Azores. Following the eruption of Capelinhos in 1957, Sen. John F. Kennedy of Massachusetts and Sen. John Pastore of Rhode Island led Congress to pass a relief act allowing 1,500 Faial victims to immigrate. Thousands were sponsored by their families in America. Kennedy wanted immigration based on skills sets needed in America, not ethnicity. After Kennedy's death, Johnson signed the bill into law. (Courtesy JAFL.)

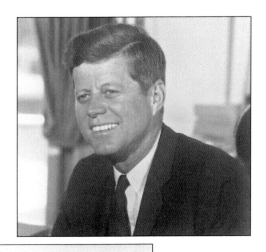

RESOLUTION NO. 3

WHEREAS, the Kennedy and Pastore Relief Bill providing for the admission of 1500 homeless persons from the Island of Faial, Azores, has been duly approved by the Senate of the United States and to become law requires only the approval of the House of Representatives;

WHEREAS, the admission of the 1500 persons from Faial contemplated by said bill would be an act of mercy and in keeping with the traditions of the United States, in receiving within its borders people who through no fault of theirs became displaced or homeless;

WHEREAS, the homeless of Faial Island have blood ties with a large segment of the population of the United States who were born or are the descendants of people from Faial, who by their outstanding qualities of character have proven to be an asset to our country and the communities where they reside;

WHEREAS, the membership of the Luso-American Fraternal Federation believes that the admission of the 1500 homeless persons contemplated under the Kennedy and Pastore Relief Bill would be for the best interest of the United States, and would strengthen the ties of friendship that bind the people of the Azores Island to the people of this country;

NOW, THEREFORE, BE IT RESOLVED, that the assembly of the Luso-American Fraternal Federation, representing 14,000 California families from every part of the State, assembled in convention at San Jose, California, go on record as indorsing the said Kennedy and Pastore Bill, and that a telegram be sent to all the California representatives in the Congress of the United States, urging upon them the approval of said bill.

KNOW ALL MEN BY THESE PRESENTS, that the undersigned, Secretary of the United National Life Insurance Society, and ex-officio State Secretary of the Luso-American Fraternal Federation, California State Council of the United National Life Insurance Society, does hereby certify that the foregoing resolution was unanimously adopted at the Annual State Convention of the Luso-American Fraternal Federation in San Jose, California, on August 19, 1958.

WITNESS my hand and seal of the Corporation this 22nd day of August, 1958.

Jack Costa
Secretary

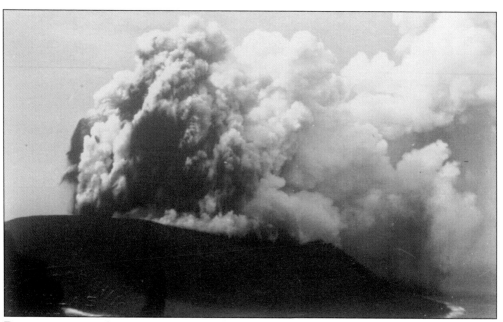

DESTRUCTION OF CAPELINHOS, 1957. This image dramatically illustrates the extent of the volcano Capelinhos's destruction. (Courtesy Carlos Almeida.)

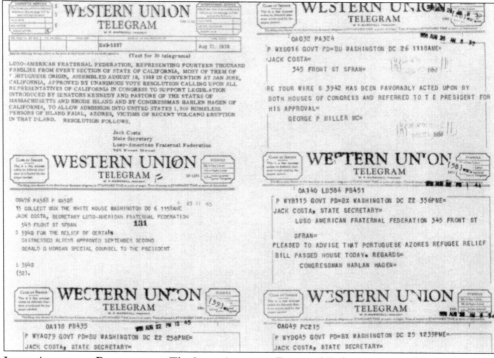

LUSO-AMERICAN RESOLUTION. The Luso-American Fraternal Federation assembled in San Jose on August 18, 1958, and approved a resolution calling for support of California congressmen for an Azorean relief act. This Western Union telegram shows the passage of a resolution in 1958 that permitted 1,500 families from Faial, homeless after the volcano eruption, to come to America. (Courtesy JAFL.)

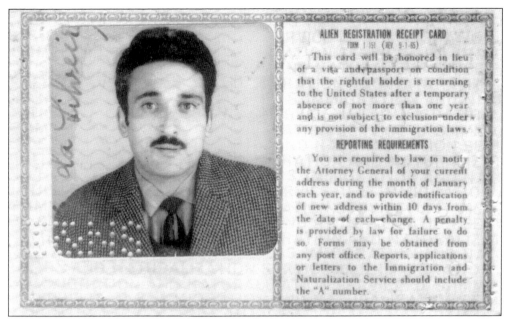

GREEN CARD. David Carvalhal da Silveira's Green Card is pictured shortly after he immigrated to the United States. In the Azores, Silveira had worked as a cobbler, taxi driver, and then as an exporter of live cows from the middle islands. People begged him to let them supervise the cows so they too could get off the island and see Lisbon. He was proud of traveling there more than 180 times. (Courtesy GS.)

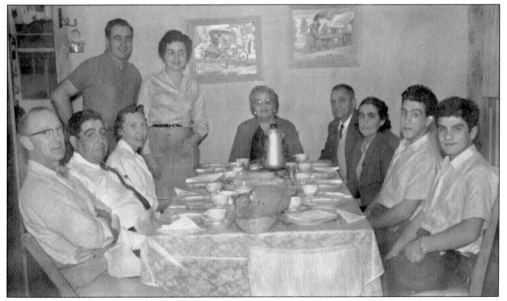

SOPA AND CARNE, 1957. Edith Mattos Lewis serves the first home-cooked meal to immigrants after the volcano. At the table are, from left to right, Victor Hanson, Frank Lewis Jr., Shirley Hanson, Rita da Silva Lewis, Frank Lewis Sr., Mrs. ? Silva, and the Silva brothers. In the back are Anthony and Edith Lewis. Through hard work, Roger Silva went on to own the Pioneer Concrete business. Edith was nervous about what to cook and finally chose *sopa* and *carne* with *linguiça* to welcome the newcomers into the community. (Courtesy EMLW.)

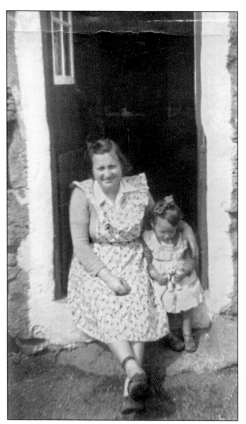

DOORWAY TO THE PAST. Goretti Silveira sits by her mother, who fixed people's hair. Even in the 1960s, Sao Jorge felt medieval—a land of little electricity and cows visible through wallboards. Goretti and her aunt had to empty chamber pots every morning. Goretti relates, "Humility is a Portuguese virtue. It works against you when you have to sell yourself and your skills in America to survive." (Courtesy GS.)

GORETTI SILVEIRA, 1966. Goretti Silveira is pictured just before she emigrated in 1966. (Courtesy GS.)

DECIO OLIVEIRA. In 1957, Decio Oliveira traveled from Faial, where there was no university or family money for school. His student visa allowed pre-dentistry study at San Jose City College. He continued at the University of California–Davis, then at San Francisco, where the admissions secretary said, "It's hard enough for the American students; you'll never make it." He earned his DDS degree, however, and established a practice with an emphasis in endodontics at 4600 Alum Rock Avenue; he ran it for 35 years. When Oliveira was 10 years old, he fell in love with poetry, especially Camoes's *Alma Minha* and Bocage's *Ja Bocage Nao Sou*. He published his first book of poems, *PO* (Dust), in 2002, followed by *Retalhos da Alma* (Shreds of the Soul) in 2005. (Courtesy DO.)

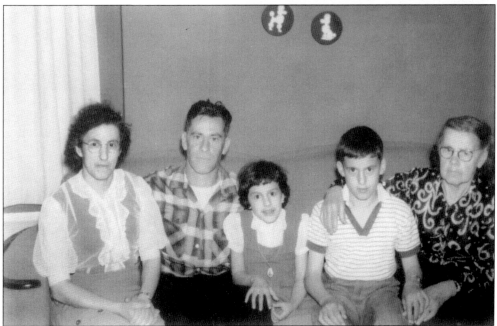

BORBA FAMILY, PORTERVILLE, 1963. From left to right are Barbara Borba, Joao Borba, Vicky (Ernestine) Borba, Vic (Honorio) Borba, and Maria Clementina Borba. Barbara wears a dress she made herself. Barcello's Dairy provided a house for the Borba family as part of Joao's earnings working as a milker for four years before moving to San Jose in 1966. The children received college educations and became successful in the community. (Courtesy VBM.)

AGOSTINO BETTENCOURT. Agostino Bettencourt (20) (left), Agustinho Santos (center), and Jaime Bettencourt (16) are pictured here. The Bettencourt brothers immigrated to the United States in 1958 and worked at a Marin dairy (now George Lucas's Skywalker Ranch). Their grandfather Manuel Azevedo Pereira had arrived in the 1880s with their mother, Ana Joaquina, hiding in a Boston-bound boat; she worked as a Yankee maid. Manuel voted for Teddy Roosevelt. Working for Albert Vieira in San Jose, Agostino Bettencourt raised a child with cerebral palsy, got a degree, and co-owned the Original Pancake House. (Courtesy MC.)

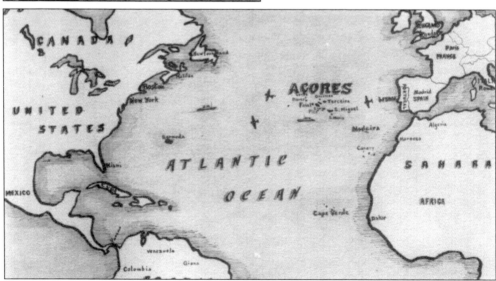

AZORES MAP, 1957. This map shows the Azores' relationship to the United States and Europe. In 1957, only Santa Maria had an airport—to leave Faial one had to take a boat to Santa Maria. The boat trip to Lisbon took a week, and travel from Faial to Santa Maria took two to three days. Boats picking up cargo and passengers stopped at Faial, Sao Jorge, Terceira, San Miguel, and then finally Santa Maria. Now all the islands have airports. (Courtesy AF.)

THE FURTADO LEGACY. Above, Gina Furtado works in the jewelry store in the 1960s; below is an early exterior shot of Furtado's Jewelers Imports. The shop was small at first but soon grew into a central axis of the Portuguese community, making banners, badges, and crowns for Portuguese societies. Confirmations, weddings, communions, and baptisms all merit gifts from Furtado's. In Faial, Antonio da Rosa Furtado helped his jeweler father purchase watches in Portugal. He immigrated in 1950, repairing watches in Massachusetts for La France. His 1957 film and book detailing the Capelinhos eruption brought the victims' plight to Congress. In 1962 in San Jose, he started International Pictures of San Jose to distribute the films and musical acts of the Azores and mainland Portugal. (Courtesy AF.)

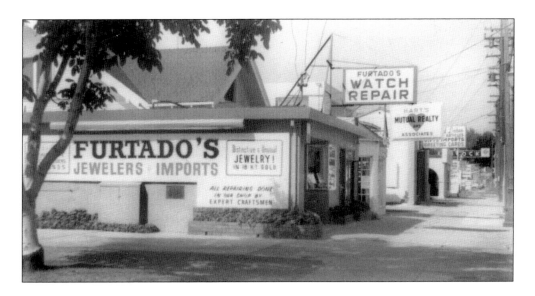

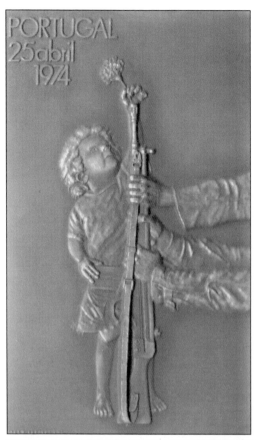

BLOODLESS COUP, 1974. This medallion (left), engraved by Lopes and Freitas, depicts the bloodless coup of Portugal in 1974, when the army ousted Americo Tomaz and Prime Minister Marcelo Caetano. After the dictatorship was put down, the Portuguese in San Jose celebrated on June 10, 1974. Below, Dr. Simao, ambassador of Portugal to the United Nations in New York, speaks about human rights at the Portuguese Athletic Club (PAC). He served as the secretary of education before the Portuguese revolution in 1974; working at his desk, he was approached by a soldier with a carnation in his gun from the Council of the Revolution. Later, as he was delivering a human rights speech as Portuguese ambassador, two men waited in the wings and told him his services were no longer required. Simao then went to live with Seabra Veiga, a cardiologist in New York who was appointed an honorary councilman of Portugal. (Courtesy PAC.)

Seven

CHANGING TIMES

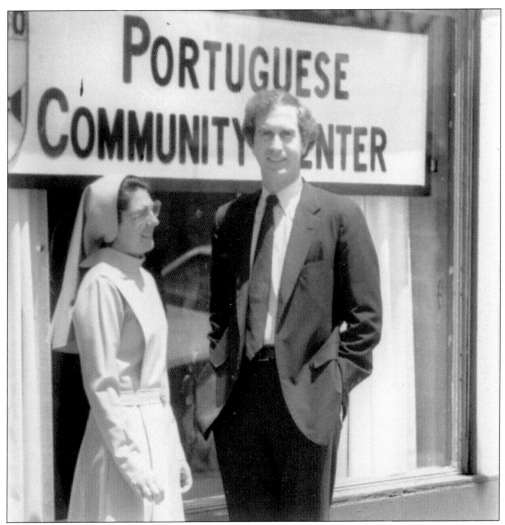

POSSO BUILDING, C. 1985. Sister Fatima and Mayor Tom McHenry converse in front of the old POSSO building on Twenty-fifth and Santa Clara Streets in San Jose. POSSO rented the old Mexican theater before it was able to buy the community center in 1985. POSSO, an abbreviation for the Portuguese Organization for Social Services and Opportunities, also means "I can" in Portuguese; the group desired to overcome the fatalism of first-generation immigrants. The mission was to provide a bridge for the community between the immigrants and the greater resources of the community, including senior services. (Courtesy POSSO.)

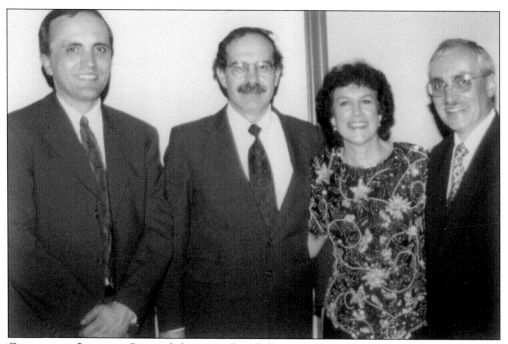

COMMUNITY LEADERS. Pictured above are, from left to right, community center founders Davide Vieira, Joe Machado, Vicky Machado, and Vic Machado. In 1974, Vicky Borba, along with her future husband Joe Machado, Ray Cota, Raquel Rodrigues, Heraldo da Silva, and Graca Moghadam, formed POSSO. Vicky was able to get the backing of San Jose State University and made establishing the community center her graduate school social work project; she continues to serve on the board and fund-raise to this day. POSSO serves the most vulnerable members of the Portuguese community—seniors and disabled people, who often only speak Portuguese and are reliant upon the group for their basic needs such as housing and medical care. Today POSSO serves around 8,000 Portuguese immigrants a year, the majority of them seniors (below). (Courtesy POSSO.)

POSSO. Joe Machado (above) and Goretti Silveira (below) pose at two different fund-raisers, selling *linguiça* and Portuguese doughnuts. In 1974, POSSO was created to help people with needs in the community. For the immigrants, relying on a nonprofit instead of a church and family was a dynamic cultural shift harder for the older generation to accept. The community took about five years to come around. In POSSO's first days at Twenty-fifth and East Santa Clara Streets, the organization was only open at night. The group had money to pay rent but not staff, so they were all volunteers. The first night, Joe Machado served as a volunteer, but not a single client entered. Through word of mouth, people heard of the organization. (Courtesy POSSO.)

THE IMPERIO. This building is a larger replica of the first imperio built at Five Wounds Church. The original imperio constructed in 1915 served as a temporary chapel before Five Wounds was built. Thoday's imperio in Kelley Park houses a museum honoring the Portuguese contributions to the Valley of Hearts Delight. The Portuguese Historical Museum is the brainchild of Joe Machado. Vicky Borba (Machado) helped found the museum, serving on the board of the Portuguese Heritage Society. Edith Walters joined them two years into the process to raise funds and collect artifacts like old trunks and lace. (Courtesy RB.)

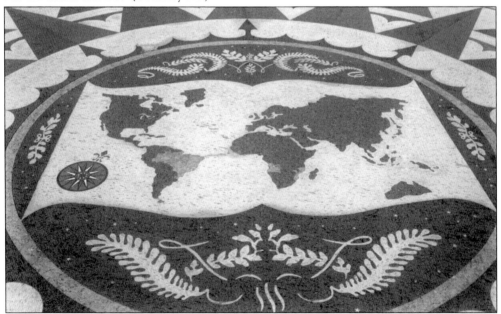

COMPASS ROSE. The plaza with the rocks is a replica of the *Praça* (plaza) of the Discoveries in Lisbon. Next to the compass rose are granite whales, commemorating early Azorean immigration. The Azorean government sent two craftsmen from Terceira to assemble the plaza by hand; it took them two months to put the stones together tongue-and-groove without any mortar or cement. At the end of the process, they added sand to keep the stones in place. (Courtesy RB.)

PORTUGUESE HISTORICAL MUSEUM. Historian Joe Machado, pictured, had visited many fraternal museums and was inspired to create a local museum. He approached the director of the History Park, Mignon Gibson, and city councilwoman Margie Fernandes. In 1993, Machado secured a grant from the California Historical Heritage Commission. He knew that a Portuguese museum could fill a *lacuna* (gap) in the Santa Clara Valley's history. The museum incorporated in 1993, broke ground in 1995, and enjoyed a grand opening in 1997. The structure includes images from the Old Country, whaling artifacts, and musical instruments. Images and relics from Portuguese fraternal organizations, Five Wounds Church, and local dairies and canneries are also on display. (Courtesy RB.)

GROUPO FOLKLORICO TEMPOS DE OUTRORA. The Groupo Folklorico serenades the crowd with traditional Azorean songs for Dia de Portugal at the Imperio in Kelley Park in 2003. Manuel Mendes stands in the second row, second from the left; to his right are Jose Farina and Filomena Roca. Manuel Terra plays the mandolin. (Courtesy PAC.)

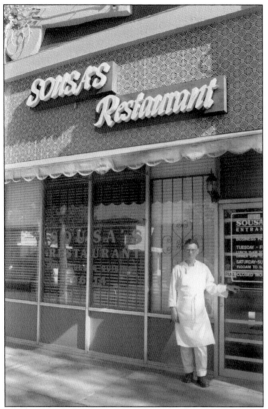

SOUSA'S RESTAURANT. POSSO members gather at Sousa's for a luncheon (below). Lionel and Aria Sousa are the proud owners of Sousa's Restaurant, located near Highway 101 in San Jose. Emigrating from the Azores 40 years ago, Lionel (left) worked at Ricky's Hyatt on his way to owning the successful restaurant. Serving Portuguese and American food, Sousa's has been a Little Portugal landmark for over 25 years. Little Portugal, the small business district across from Five Wounds Church on East Santa Clara Street, heads over the freeway on Alum Rock, sprinkled with Portuguese establishments. Fastidious business ethics sparkle from businesses such as Silva Sausage, Furtado's Jewelers, Casanova Imports, Vieira Painting, Foto Christiano, Five Star Bakery, and KSQQ radio. (Courtesy RB.)

Eight

PROGRAMS AND PERSONALITIES

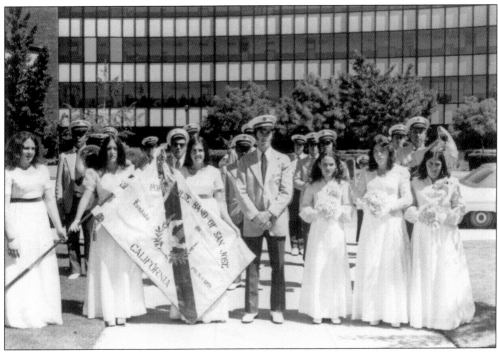

PORTUGUESE BAND OF SAN JOSE. The Portuguese Band of San Jose plays while the flag is being raised at city hall for Portuguese Day on June 10, 1972. The flag raising has commemorated the Portuguese contributions to the area since 1970. June 10 was originally known as Dia de Camoes, or Day of Camoes, to celebrate the great Portuguese poet Camoes. In 1974, Dia de Portugal was designated as a celebration of the bloodless coup, or "Carnation Revolution," when soldiers ousted Salazar's regime carrying firearms with carnations in their guns. (Courtesy DO.)

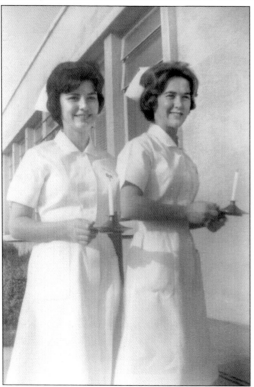

MISS PORTUGAL, 1960. Maria Santos meets UPEC president Joseph A. Freitas while he is on an official visit to San Jose. Pictured here, from left to right, are Louis Silva, UPEC vice president; Freitas; Santos; and Carlos Almeida, UPEC secretary-treasurer (a post he held for 36 years). Almeida founded UPEC's J. A. Freitas Library in San Leandro, which houses records, newspapers, magazines, and microfilm on the Portuguese in California from the 1800s to the present day. The library accepts donations and appointments for research. (Courtesy Carlos Almeida.)

O'CONNOR NURSES, 1963. Susan Vargas (left) poses with her roommate, Karen Fanoe, at O'Connor Hospital School of Nursing after taking the Florence Nightingale Nursing Pledge, which included lighting a candle and vowing compassion. (Courtesy SV.)

FRESNO SOCCER GAME. The Portuguese Athletic Club soccer league founded in 1962 continues to this day. PAC members Augusto Rosa, Marian Gill, Adelia Gill, Rita Leal, Helena Oliveira, Maria Silveira, Decio Oliveira, Albert Soares, and John Silveira are among those attending a Fresno soccer game. PAC hosted tournaments throughout the state, including games at Fresno, Los Angeles, and Stanford. (Courtesy PAC.)

PAC SCHOLARSHIP. PAC gives a scholarship to Manuel Gaspar. From left to right are Jose Silveira, Manuel Gaspar, Decio Oliveira, and Antonio Bettencourt (far right, Portugal's vice counsel). This same year, 1974, PAC gave a $2,000 scholarship to Al Graves, who wrote *The Portuguese in Agriculture*. According to Dr. Bettencourt of the Luso-American Fraternal Federation, students wishing to study at UC Berkeley may apply through the Portuguese Studies Program under an $8-million endowment for Portuguese students admitted to UC Berkeley. The requirements are to have at least one grandparent of Portuguese descent. Students may study any subject at the undergraduate or graduate level. Parents' income level is not a factor, nor is the student's age. (Courtesy PAC.)

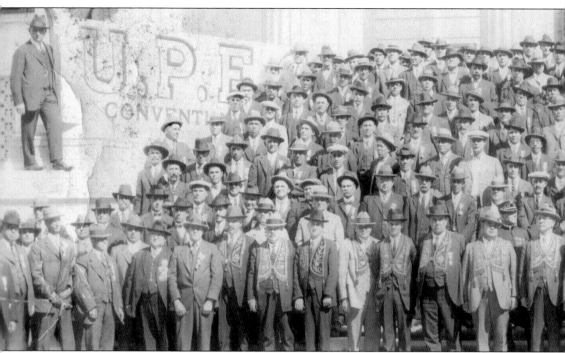

UPEC Convention, 1925. Among those shown here are Alfred Gaspar, John Mattos, Joseph Freitas, Francisco Lemos, Manuel Fraga, and Firmino Cunha. In 1925, UPEC met in front of the Scottish Rite Hall in San Jose. Some 1,627 candidates from San Jose and the surrounding areas were initiated at the St. James Hotel in the Rose Room. UPEC Council 32 was founded in San

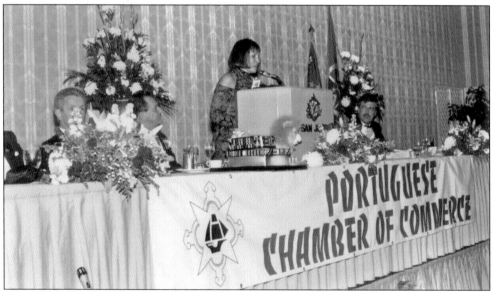

The Portuguese Chamber of Commerce. In the 1980s, school owner Goretti Silveira would address the Portuguese Chamber of Commerce. This organization encourages businesses to work together and helps project a positive image of the Portuguese American community. It helps strengthen their professionalism and encourages trade with Portuguese-speaking countries. (Courtesy GS.)

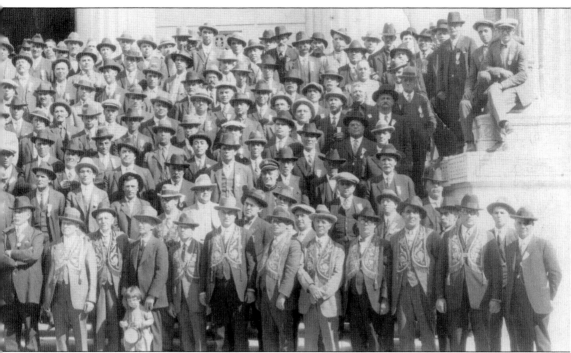

Jose on November 21, 1897. The convention lasted several days, with a concert led by UPEC bandleader Mario B. da Camara at St. James Park and a mass at Five Wounds in honor of St. Anthony, UPEC's patron saint. (Courtesy Carlos Almeida.)

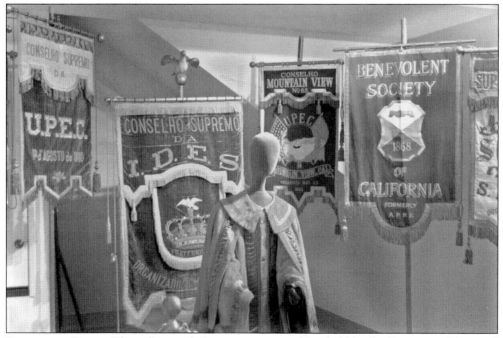

FRATERNAL FLAGS. These flags and plaques are among those held by the Portuguese Historical Museum of San Jose on Senter Road in History Park. (Courtesy RB.)

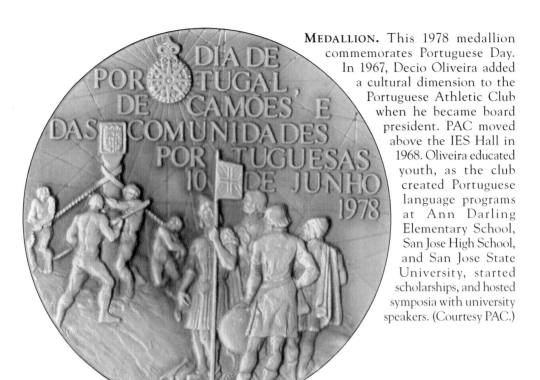

MEDALLION. This 1978 medallion commemorates Portuguese Day. In 1967, Decio Oliveira added a cultural dimension to the Portuguese Athletic Club when he became board president. PAC moved above the IES Hall in 1968. Oliveira educated youth, as the club created Portuguese language programs at Ann Darling Elementary School, San Jose High School, and San Jose State University, started scholarships, and hosted symposia with university speakers. (Courtesy PAC.)

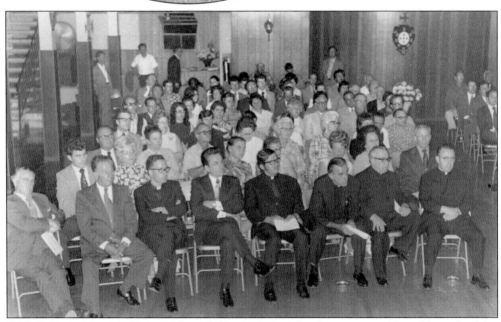

PAC LECTURE, 1974. Pictured from left to right, in the first row are Alan Alameda, John Soares, Fr. Abano Oliveira, Joaquim Esteves, Fr. Leonel Noia, Msgr. Manuel Alvernaz, Conego Eugene Alves, and Fr. Charles Macedo. Dr. Jorge De Sena, head of the Portuguese and Spanish Department at the University of California–Santa Barbara, lectures on Camoes for Portuguese Day. (Courtesy PAC.)

O'CONNOR AND SAN JOSE HOSPITALS.
Iris "Jonnie" Moitozo got her nickname
in nurse's training at O'Connor Hospital
in the 1950s. Portuguese nurses also
worked at San Jose Hospital (below).
Susan Vargas (pictured at right) wanted
to be a nurse. Her mother, Isabel Vargas,
could not go to school and so, instead,
sent Susan to Notre Dame in San Jose
with German Dominican nuns. When
Susan contemplated becoming a nun, her
mother pleaded, "Try nurse's education
and later think about becoming a nun."
Susan says, "In 1956, the O'Connor
nurses in training were the first women
allowed on the campus at the Jesuit
University of Santa Clara." Sister Anita
was the program's nursing director
in 1962. Born in 1988 at O'Connor,
Olivia Teixeira wants to become a nurse
practitioner and attend Jesuit University.
She was a 2005 Holy Ghost Festa maid.
Her grandmother has told her to marry a
Portuguese man because intermarriages
have torn the community apart by
creating divided loyalties between
cultures. (Courtesy SV.)

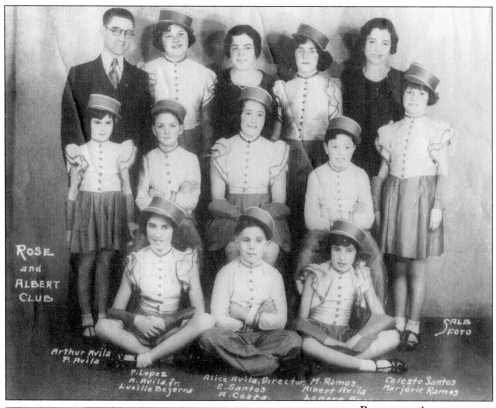

ROSE and ALBERT CLUB

Arthur Avila
P. Avila

F. Lopez
A. Avila, Jr.
Lucille Bejerra

Alice Avila, Director, M. Ramos
E. Santos
A. Costa.

Albert Avila
Lenore R.

Celeste Santos
Marjorie Ramos

SALB FOTO

ROSE AND ALBERT CLUB, 1930s. Arthur Avila stands with the Rose and Albert Club. (Courtesy EMLW.)

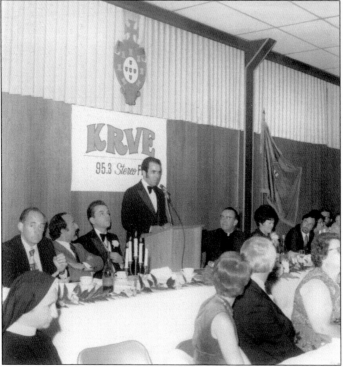

KRVE INAUGURATION BANQUET, 1974. Batista Vieira addresses the IES Hall about his plans for KRVE. Seen on the dias from left to right are two unidentified people, Joaquim Esteves, Batista Vieira, Father Macedo, Isabel Esteves, and four unidentified people. The nun in front is Maria Amelia, the principal of Five Wounds at the time. (Courtesy Vieira family.)

Nine

ARTS AND
ENTERTAINMENT

JOAQUIM ESTEVES, 1950S. This popular radio personality, originally from the Azorean island of Terceira, came to the San Joaquin Valley at age 12. The handsome, friendly Esteves moved to East San Jose, buying a house on Willow Street and working as a Portuguese radio announcer for KRVE in Los Gatos. Joaquim Esteves was a lady-killer; they flocked to him like they did to Frank Sinatra. He used his popularity to raise nearly $1 million for the victims of the 1957 earthquake in Faial before disappearing under mysterious circumstances en route to his radio station in Los Gatos. Authorities never found his body but did discover his personal effects, including his wristwatch, in the car of a man who was jailed. Esteves's wife was unable to prove that her husband was missing and had to wait seven years before she was able to settle the estate. (Courtesy EMLW.)

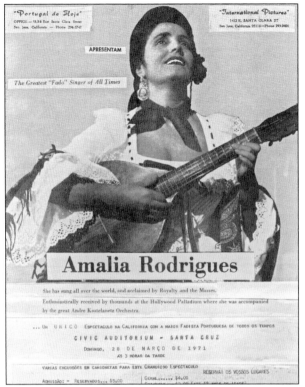

Amalia Rodrigues

She has sung all over the world, and acclaimed by Royalty and the Masses.
Enthusiastically received by thousands at the Hollywood Palladium where she was accompanied
by the great Andre Kostelanetz Orchestra.

... Um U N I C O Espectaculo na California com a maior Fadista Portuguesa de todos os tempos

C I V I C A U D I T O R I U M — S A N T A C R U Z

Domingo, 2 8 D E M A R Ç O D E 1 9 7 1
AS 3 HORAS DA TARDE

VARIAS EXCURSÕES EM CAMIONETAS PARA ESTE GRANDIOSO ESPECTACULO
RESERVAI OS VOSSOS LUGARES
Admissão: — Reservados... $5.00 Geral...... $4.00

INTERNATIONAL PICTURES OF SAN JOSE. Antonio Furtado started International Pictures of San Jose to promote Portuguese singers and to show the films of the Azores and Portugal. Furtado's imported films and musical acts played throughout California. He became friendly with Portuguese film stars and singers such as Amalia Rodrigues and Alberto Ribeiro. (Courtesy AF.)

MUSIC OF THE AZORES. When John Rose goes to the Old Country to visit his mother, Maria Rose, he enjoys listening to traditional tunes. (Courtesy Moitozo.)

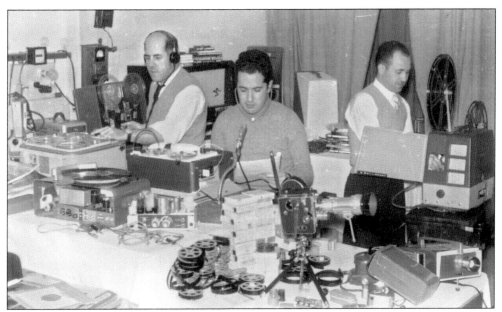

ILHAS DE SONHO. In 1959, Furtado directed, produced, and shot the film *Açores, Ilhas de Sonho,* working with music coordinator Carlos Ramos Jr. and writer-narrator Fernando Melo. The film showed the beauty of the Azorean archipelago—today it is a record of Azorean life before modernization. (Courtesy AF.)

RUI DE MASCARENHAS, 1966. Shown from left to right are Antonio Furtado; Gilberto Lopes Aguiar, publisher of *Voz de Portugal* newspaper, singer Rui de Mascarenhas; and Joaquim Esteves. Mascarenhas was at Aguiar's office for a visit. (Courtesy AF, *Voz de Portugal*, April 12, 1966.)

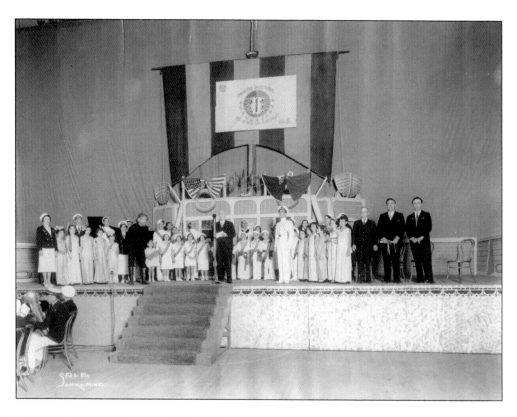

ECOS OF PORTUGAL, KTAB. At the Oakland Auditorium in 1933, San Jose radio star Lionel Soares de Azevedo appears in front in a white cap. Soares de Azevedo and Artur Avila had a radio "war," as each vowed to raise more money than the other. Avila's Rose and Albert Show sold red tickets and Soares de Azevedo's sold green tickets. Afterward, the two went out to dinner and split the proceeds. (Courtesy JAFL.)

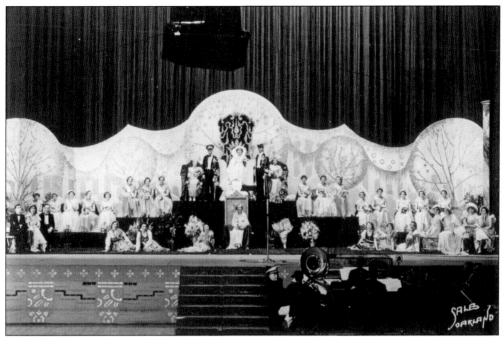

VOICE OF PORTUGAL, 1930S. Thomas Dias, a radio personality for the Voice of Portugal Radio Association, stands in the fourth row, third from the left. In the late 1930s, Voice of Portugal Radio played Portuguese music over KLS radio station, broadcasting to the Portuguese community in San Jose. (Courtesy EMLW.)

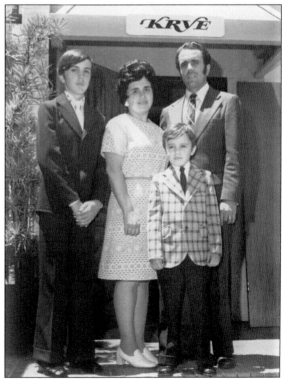

KRVE, 1974. Pictured from left to right are Davide Vieira, Dolores Vieira, Joseph Vieira, and Batista Vieira on the day partners Rosa, Vieira, and Esteves acquired a floundering Los Gatos station from "the hippies," according to Batista Vieira. When they walked in to inspect the building, they had to jump over sleeping dogs. In the 1950s and 1960s, Bay Area stations limited foreign language programming to one or two hours a week. KRVE sold 24 time slots for shows like Joaquim Esteves's "Portugal de Hoje" and "Ventura Portugal Moderno" and broadcast news from mainland Portugal. In 1987, the two stations KRVE and KLBS were divided, with Rosa taking KRVE and Batista Vieira taking Los Banos's KLBS, which still features Portuguese programming. (Courtesy Vieira family.)

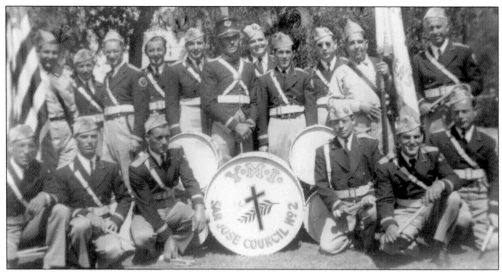

DRUM CORPS, 1957. Joseph Lewis supports the American flag. Also seen are Anthony Lewis (5th from the left), drum major "Babe" Oliver (middle), and Frank Lewis (10th from the left), who holds up the Young Men's Institute (YMI) banner. YMI played Festa Holy Days and marched in Veteran's Day parades throughout the valley. (Courtesy EMLW.)

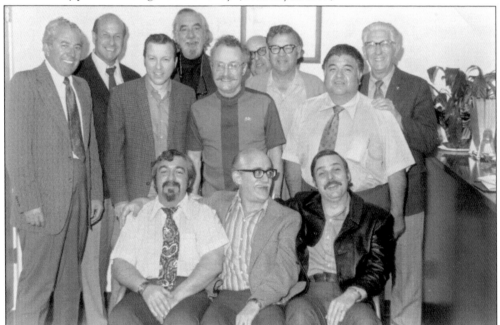

LOCAL 153 OFFICER INSTALLATION, 1973. Joining the musicians' union in 1973, Dick Carlo spearheaded a healthcare program for its members. Shown here, from left to right, are the following: (first row) Harvey Leventhal, secretary-treasurer; Elvin "Blackie" Perry (Perreira), black belt and former musicians' union secretary-treasurer; and Dick Carlo, board member; (second row) Mike Mello, saxophone player; Neil Schebetta, another saxophone player; Don Hoque, bass player; Orin Blattner, musicians' union president and charter member of the San Jose Symphony; front and center, Chuck Travis (who played with Count Basie and the Dorsey Brothers); Frank Higuera, bass player and board member; William Burnell; Connie Caudillo; and S. Casselli. (Courtesy DC.)

THE BAND, 1956.
Dick Carlo grew up to be an art educator at San Jose High Academy in 1988. In 1986, the California Fine Arts Council gave Carlo a grant to teach percussion to students from San Jose Unified. He received the grant before the National Endowment for the Arts funding dried up in the mid-1990s, when many music and art educators were forced into private teaching or other pursuits. (Courtesy DC.)

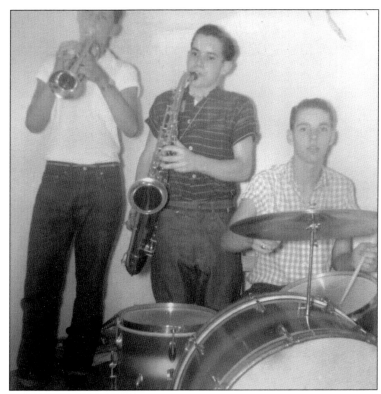

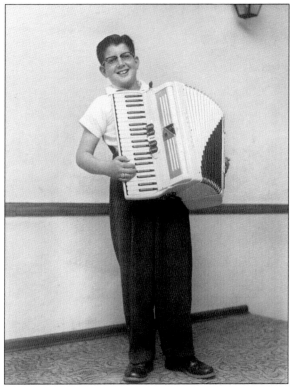

ACCORDION PLAYER. The grandson of the first Five Wounds queen, Margaret Cardoza, William Chiechi performed on television in an amateur competition on the *Ted Mac Show*. He went on to have a professional music career with shows in Vegas, Tahoe, and on the Fun and Snow Trains to Reno. (Courtesy PV.)

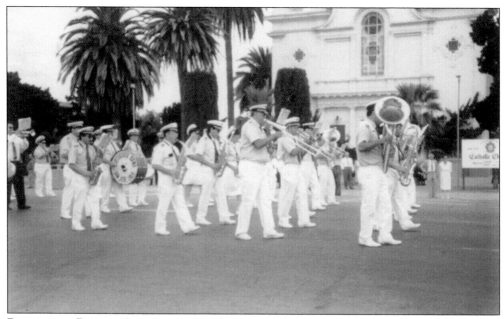

PORTUGUESE BAND OF SAN JOSE, 1972. The group marches past Five Wounds National Portuguese Church. The Portuguese have three very active bands: the Portuguese Band of San Jose, Nova Aliança of San Jose, and Uniao Popular. (Courtesy DO.)

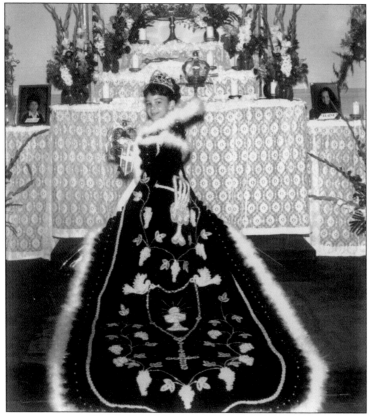

SAN JOSE IES LITTLE QUEEN. Christina Bettencourt wears the Holy Ghost Fest cape with the traditional motifs of the Holy Spirit crown, the white doves symbolizing the Holy Spirit, the chalice representing the blood of Christ, and the host above the chalice. (Courtesy MC and PHPC.)

FISHING IN HALF MOON BAY. There were big fish to catch at Half Moon Bay and all around the Bay Area. Among those identified are John Rose (second from the left) and Manuel Rose (third from the left). (Courtesy Moitozo.)

MOITOZO RANCH AND PARK. On June 25, 1920, Manuel Moitozo bought the Moitozo Ranch from Jose Silveiera Marques, paying $20,000 in gold coin—proceeds he had saved working hard in the Philips Brothers Dairy in San Leandro. During World War II ,when his neighbors, the Okubas on River Oaks, were taken to Japanese internment, Moitozo took care of their ranch. Manuel's son Mac Moitozo and Walter Cnkovich drove a 1940 Pontiac to Ogden, Utah, so their school friend Tom Okuba could be let out to work for his family. These Portuguese, Japanese, and Czech American friends were forerunners of today's San Jose—one of the most ethnically diverse cities in America. In 2003, San Jose mayor Ron Gonzales dedicated Moitozo Park on Rio Robles and First Streets. It is one of the many significant, lasting contributions of the Portuguese in San Jose to the greater community's future. (Courtesy Moitozo.)

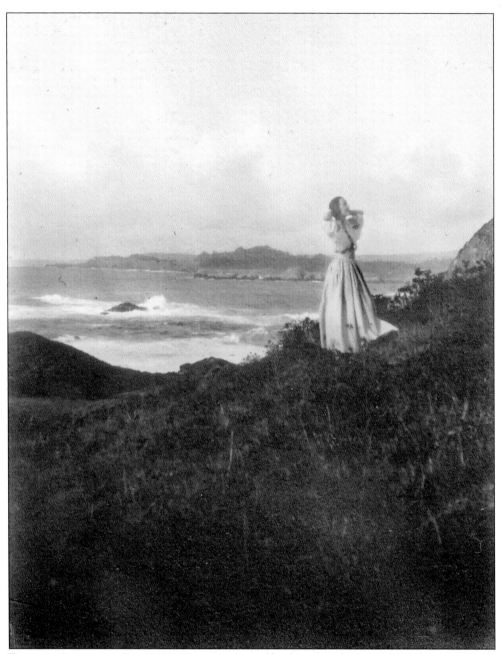

BETWEEN LAND AND SEA, 1939. Peggy Vargas and her best friend, Mrs. Kelley's daughter, Flavia Flavin, would stroll Carmel's rugged cliffs. Like many Portuguese Americans, Peggy was drawn back to the sea. She has known a full life in San Jose: her grandparents grew apricots near Mount Hamilton; her aunt Sr. Mary Imaculada traveled the world as an educator; her father created city parks for generations to come. The estate she grew up on houses today's Portuguese Historical Museum. Even though they cultivated and culturally enriched the Santa Clara Valley from the Gold Rush period through the millennium, settlers of Azorean descent sometime miss the wind-swept islands. But like the romantic figure poised here between land and sea, rich Old World roots have helped them flower in their new home. (Courtesy PV.)

BIBLIOGRAPHY

Almeida, Carlos. *Portuguese Immigrants: The Centennial Story of the Portuguese Union of the State of California*. San Leandro: UPEC, 1978, 1992.

Furtado, Antonio da Rosa. *Açores e o Vulcao dos Capelinhos*. New Bedford: DuMont Printing, 1957.

———. *Açores, Ilhas de Sonho*. 1959.

Goulart, Tony. *The Holy Ghost Festas: A Historic Perspective of the Portuguese in California*. San Jose: Portuguese Heritage Publications of California, 2003.

Graves, Alan Ray. *The Portuguese Californians: Immigrants in Agriculture*. San Jose: Portuguese Heritage Publications of California, 2004.

Vaz, August Mark. *The Portuguese in California*. Hayward: IDES Supreme Council, 1965.

Photographs are acknowledged as follows: Edith Mattos Lewis Walter (EMLW), Portuguese Historical Museum (PHM), Joe Machado (JM), Vicky Borba Machado (VBM), Richard Alves (RA), Clare Alves (CA), Peggy Vargas (PV), Uniao Portuguesa do Estado da California (UPEC), J. A. Freitas Library (JAFL), Dick Carlo (DC), Antonio Furtado (AF), Goretti Silveira (GS), Tony Goulart (TG), Lynn Rogers (LR), Mabel Silva Mattos (MM), Portuguese Organization for Social Services and Opportunities (POSSO), Dr. Decio Oliveira (DO), Portuguese Athletic Club (PAC), Portuguese Heritage Publications of California (PHPC), Dick Santos (DS), Robert Burrill (RB), Mac and Madeline Moitozo (Moitozo), Davide Vieira (DV), Susan Vargas (SV), and Maria Cunha Carty (MC).

Discover Thousands of Local History Books Featuring Millions of Vintage Images

Arcadia Publishing, the leading local history publisher in the United States, is committed to making history accessible and meaningful through publishing books that celebrate and preserve the heritage of America's people and places.

Find more books like this at
www.arcadiapublishing.com

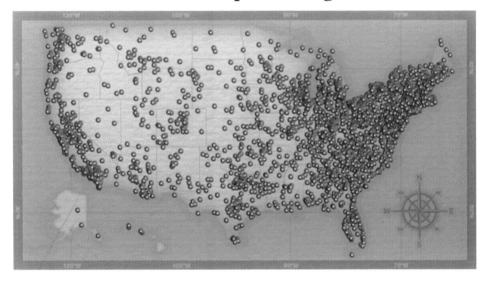

Search for your hometown history, your old stomping grounds, and even your favorite sports team.

Consistent with our mission to preserve history on a local level, this book was printed in South Carolina on American-made paper and manufactured entirely in the United States. Products carrying the accredited Forest Stewardship Council (FSC) label are printed on 100 percent FSC-certified paper.

MADE IN THE USA